COMPOSITION

by J. M. Parramon

Published by
H.P. Books
P.O. Box 5367
Tucson, AZ 85703
602/888-2150

ISBN: 0-89586-084-8
Library of Congress Catalog
Number: 80-83273

Publishers: Bill and Helen Fisher
Executive Editor: Carl Shipman
Editorial Director: Rick Bailey
Editor: Randy Summerlin
Art Director: Don Burton
Design & Assembly: George Haigh
Typography: Cindy Coatsworth, Joanne Nociti, Michelle Claridge

Published in Great Britain by
Fountain Press
Argus Books Ltd.

Second Edition in English, 1978

Original title in Spanish
Asi se compone un cuadro
© 1974 Jose M.a Parramon Vilasalo

Deposito Legal: B. 30.158-78
Numero de Registro Editorial: 785

ON THE COVER: **Paul Cézanne's *Still Life with Sugar Bowl*** (detail).

CONTENTS

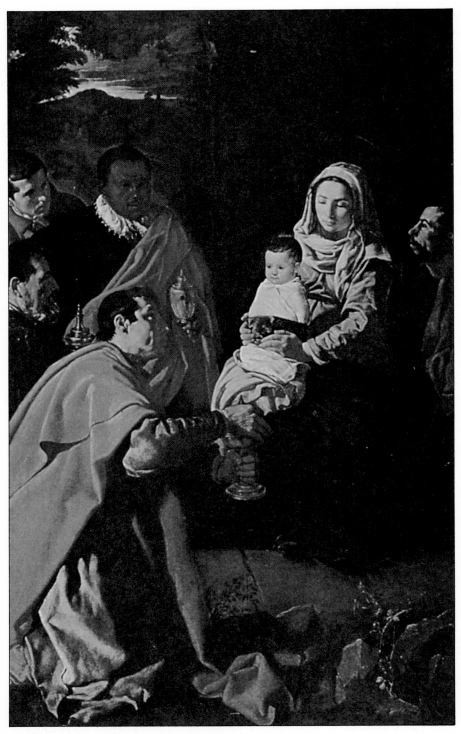

Diego Velazquez. *The Adoration of the Magi.*

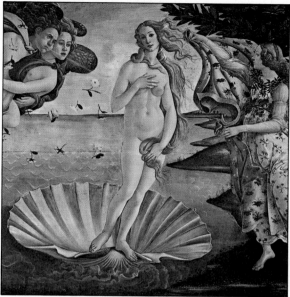

Basic Principle
Terms
Golden Section Principle
Symmetry
Asymmetry
Traditional Types
of Composition

Sandro Botticelli. *The Birth of Venus* (detail).

WHAT IS COMPOSITION?

Composition is a key element in drawing and painting. This is true no matter what artistic style or movement is involved, whether Impressionist, Classical, Modern or Abstract.

Composition is one of the most complicated and fascinating subjects in art. It's impossible to draw or paint a *good* picture without understanding composition.

Composition is *the positioning of all parts in a picture.* It is the *rhythm* or *repetition* of parts in a picture. It is the arrangement of different shapes to *unify* everything around the *center of interest* or *focal point* of the work. It is always *essential* to good art.

Abstract art is based to a great extent on composition. Henri Matisse declared, "The whole effect of my painting depends on composition. The place occupied by figures and objects, the empty

spaces around them, their proportions, each has its place." Many famous abstract paintings—such as those of Piet Mondrian—have the word *composition* before the picture's title.

BASIC PRINCIPLE

Plato, the famous philosopher of ancient Greece, summed up the complex art of composition in a single phrase. He explained that composition consists of *diversity with unity.*

This observation can be stated in reverse order. Stated either way, it gives us two guidelines that are basic requirements for any work of art. These help describe the principles of composition.

DIVERSITY with unity

Let's define what that statement means. Diversity, as we use the term, can be defined as *variety.* This includes variety in line, color, shape, position and size of all elements in a picture.

The eye is attracted to a picture when diversity contributes to the overall effect. Diversity *catches your eye* and *increases your interest.*

Diversity can be overdone. It should not detract from and destroy the work's appeal. The *whole* painting must be more important than the *parts.*

UNITY with diversity

Unity can be described as *order.* We enhance order by combining all elements of a work—line, size, color, shape and position—into a *harmonious whole.*

Use the following principles to enhance unity in a drawing or painting:

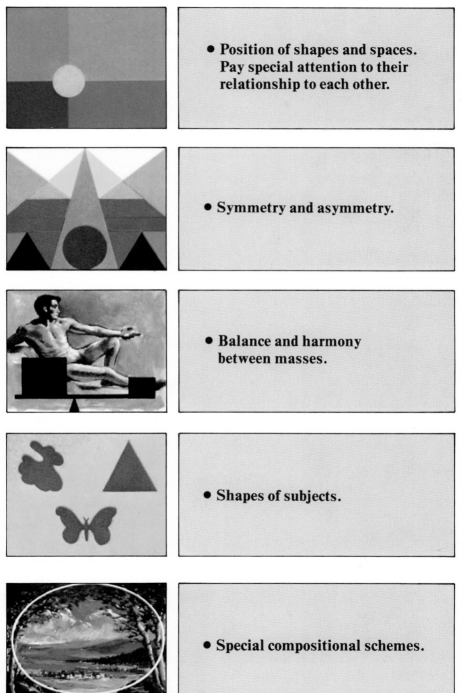

● Position of shapes and spaces. Pay special attention to their relationship to each other.

● Symmetry and asymmetry.

● Balance and harmony between masses.

● Shapes of subjects.

● Special compositional schemes.

Remember the following principles to achieve diversity:

- **Develop repetition.**

- **Develop contrasts.**

- **Develop dramatic possibilities.**

- **Heighten the theme through materials and techniques.**

- **Plan a balanced composition.**

These procedures and how to use them are the subject of this book.

They are used to create diversity with unity and unity with diversity. All can be called on to focus attention on the painting's center of interest.

The following statements help sum up these principles. They can serve as guidelines in planning a composition.

- **Diversity and unity can be used to emphasize the center of interest.**

- **A good relationship between unity, diversity and center of interest creates *rhythm*.**

- **Rhythm can be the basis and essence of a painting's artistic value.**

Terms

Before we examine how to use *unity* and *diversity* in drawing or painting, let's define some terms used in this book.

Asymmetry—Lack of symmetry or balance. See *symmetry.*

Axis—An imaginary straight line. It can run down the center, or across the center, of your painting or drawing. You can measure from this line to position parts of your picture. Symmetry, or the lack of it, is measured from the axis. The axis can also be the centerline or midline of any object or shape.

Center of Interest—One object, shape or point of interest that is more important than others in a painting. All the rest are less important than the main element. Diversity and unity should be used to emphasize the *center of interest*, or focal point.

Composition—Composition is the *positioning* of all parts in a painting or drawing. The work should have rhythm, harmony and a center of interest.

Harmony—The pleasing relationship or combination of elements in a composition. Harmony exists when there is a feeling of *order* in the composition. Harmony is the result of rhythm or repetition.

Line—One of the fundamental tools in art. Line can suggest mass, texture, light and shadow. It can have its own character, from an irregular scribble to a smooth curve.

Mass—Any shape that has two or three dimensions—especially *depth*—even when represented on a two-dimensional surface such as a canvas. It has thickness or roundness. Or it may be a flat shape. The appearance of mass is usually achieved with light and shadows, or by the placement of shapes.

Order—There is order in a composition when the elements are arranged in a *methodical* or *logical* way.

Plane—A plane can be thought of as an *imaginary flat surface* that extends an infinite distance in any direction. Think of a *pane of glass*. Lining up several panes of glass would be similar to successive planes. Visualize two panes of glass that are perpendicular to each other. They are *intersecting planes*.

Rhythm—A good relationship between unity, diversity and the center of interest gives the work *rhythm*. Rhythm is the composition's *repetitive patterns* that establish artistic eye appeal. Rhythm can be achieved by lines, shapes and colors.

Shape—Any area with clear boundaries. It has two dimensions: length and width.

Symmetry—Balance of shapes and masses on both sides of an axis, line or plane. A composition or painting is called *symmetrical* if it can be divided into halves that are similar in appearance. See *asymmetry*.

Value—Refers to the relative *lightness* or *darkness* of a color. *Value* means a color's lightness or darkness as compared to adjacent or nearby colors.

Viewfinder—A rectangular opening, usually in cardboard, through which the artist looks at the subject of the painting as shown on page 64. Use it to determine what portions of the subject to include in the painting. Move it closer to your eyes or farther away to visualize what size to make the subject on your painting surface. A viewfinder is helpful in planning a composition.

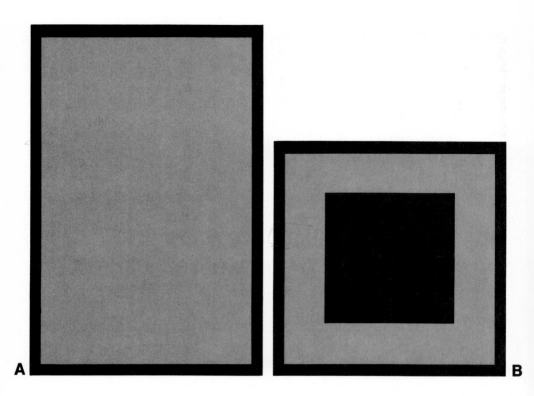

A B

DIVERSITY WITH UNITY

Let's make a practical study with diagrams. We'll start with the two basic principles that we apply to composition: *Diversity with unity* and *unity with diversity.*

Look at the gray rectangle with a black border, figure A. The gray might be considered monotonous by many viewers. It lacks variation in value. There is no center of interest. The gray rectangle fails to produce any artistic pleasure. This kind of picture is the opposite of diversity. This box lacks *variety.*

Next, look at the smaller box, figure B. It has the same gray background and black border. But we have changed the shape to a square and added a smaller square in the middle. This has more variety, but it is not pleasing to the eye. We have one square drawn inside another. The two shapes are identical and the color contrast is boring. This is also the opposite of diversity. It does not arouse interest.

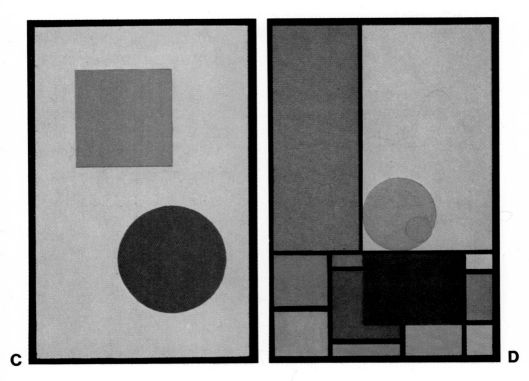

C D

The next picture, figure C, shows a red square placed above an off-center blue circle. These are on a light blue rectangle with a black border. There is some diversity in this arrangement. But the geometrical shapes portray nothing in particular. The background is a rectangle, which is usually more interesting than a square. The square and the circle don't resemble each other or the rectangular background. The colors of each element of the picture are not contrasting enough to be interesting.

Figure D captures your attention. It has a greater number of shapes in various colors, positions and sizes. This is a better example of diversity.

But diversity isn't everything. A work of art should be complex enough to stimulate our interest. But it should not be so complex that it exhausts us. *To be pleasing, diversity should have a balance between simplicity and complexity.*

UNITY WITH DIVERSITY

We strive for diversity to add interest in art. We achieve *order* when diversity is well-planned.

Let's get away from imaginary forms and ideas and consider a more realistic scene. We'll begin with a still life showing two peaches, a banana, pear, plate and knife—all set out on a table. Let's try to arrange them in an interesting composition.

Our first attempt is shown in figure A. There is diversity here. The objects give us plenty of variety: spherical peaches, long banana, rounded pear, circular plate and the straight line of the knife.

Composition of the elements could hardly be more varied. The plate of peaches is at the top, banana at right, knife below it and pear at bottom left. Each object is isolated.

But would you call this diverse composition pleasing? Would you want to stand and gaze at this kind of picture? Obviously not. It's an example of poor composition—scattered. There is no harmony.

The difference in size of the articles and the space around them makes them look too small. They are practically lost on this vast table. This arrangement of objects is *boring*. Your eye darts from side

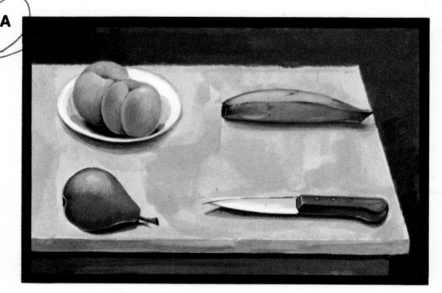

A

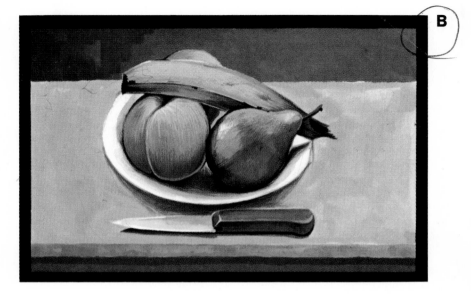

B

to side. *There is no center of interest.* The interest that might lie in the pear conflicts with the peaches. The similar positions of the banana and the knife seem too repetitive.

The fault lies in *lack of unity.*

Now we must create unity by putting everything together, collecting the fruit on the plate. Let's put the knife in front of the plate and make a solid mass, as in figure B. How does that look?

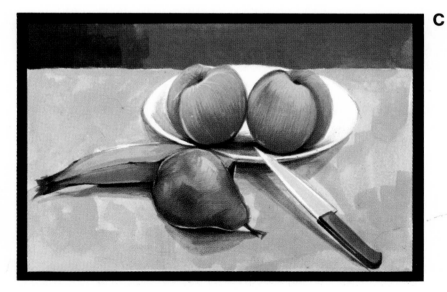

C

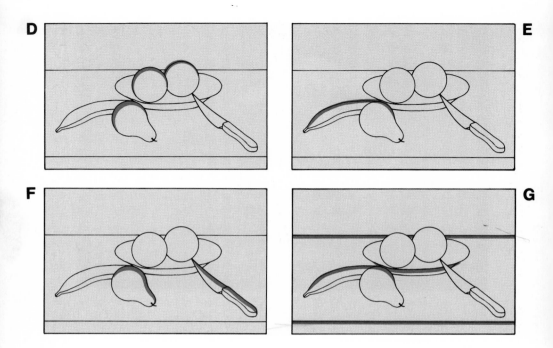

Unity is fine. But for diversity it's a disaster. Unity is overdone and the composition has become too simple. We must try something else: *Unity and diversity must be combined.*

The next picture, figure C on page 15, shows a more appealing composition. There are two groups. One is in the foreground with the pear and the banana. The other is behind with the two peaches and the plate. The knife stands alone. We get unity by superimposing the first group on the second. There is variety here, but it is still not an acceptable composition.

Look at the analysis of the composition above and let's determine what is missing.

Notice the repetitive shapes formed by the curves of the peaches and the pear in figure D. This arrangement is too regular and looks too deliberate. There is little contrast and the masses are too centered. Diversity has not been seriously considered.

Lack of diversity is also apparent in the curve produced by the upper edge of the banana and the pear in figure E.

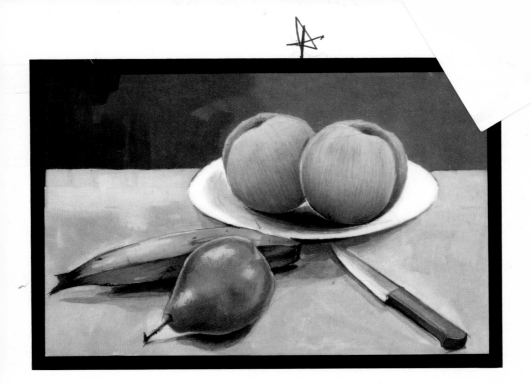

The line of the knife is repeated by the upper edge of the pear in figure F.

The curve of the pear and banana running into the edge of the plate is not pleasing to the eye, as shown in figure G. The same is true of the line of the far edge of the table. The line runs into the upper edge of one of the peaches. The near table edge makes a dark border that has no purpose. It is distracting.

The next composition, figure H, is much improved. Compare the previous outlines with this more successful composition. Notice how we have broken the repetitive shapes formed by the curve of the peaches and the pear. We have turned the pear around so it points to the left and is more centered.

The banana is nearly horizontal. This stops the inartistic sweep of the upper lines of the two fruits. The harsh line made by the edge of the plate and the top of the pear and banana is also broken. Compare the new position of the knife.

Notice that we have shifted the whole subject back a little. This lowers the far edge of the table and places the peaches against a dark background. We have also removed the obtrusive front edge of the table that was so noticeable in the previous sketches.

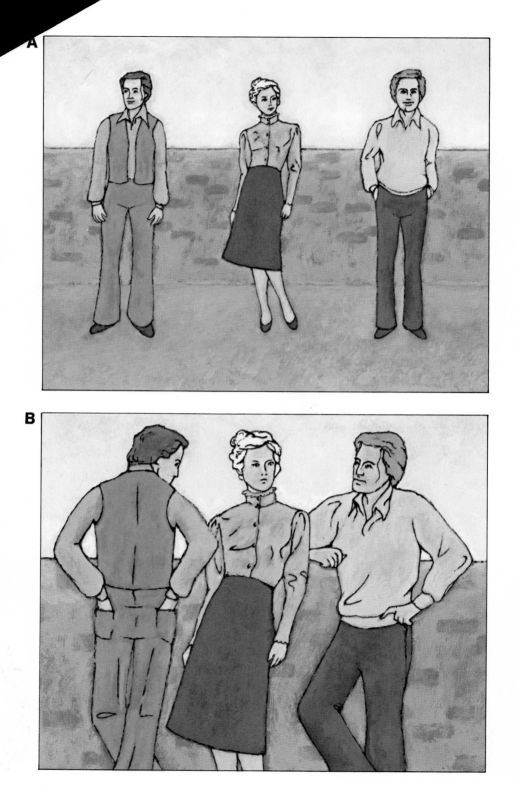

A

B

Composing a Group of People—Let's examine unity with diversity regarding a group of people. Visualize two men and a woman chatting in a garden.

Look at the composition in figure A on the opposite page. Placing the people this way, equally spaced and in similar poses, makes a dull group. It seems artificial, too formal. It implies that everything is equal in importance.

Unity with diversity can be achieved by grouping the three people together and positioning one behind another, as in figure B. This creates *depth* and gives an interesting, varied group. It fulfills the unity principle and brings the elements of the picture closer.

Composing a Landscape—Let's work with a landscape scene. We can compose a landscape using the basic principles of diversity and unity.

Here the theme is set at the start. In a landscape we don't have the freedom of a still life. We can't move trees, mountains or houses around if we want an accurate picture. We must take them as we find them. We must find a *viewpoint*—or position from which to view the scene—so that the composition will have diversity and unity.

Look at figures C and D below. The first shows a view seen head-on. Unity is nearly absent. The white of the road in the foreground is

C

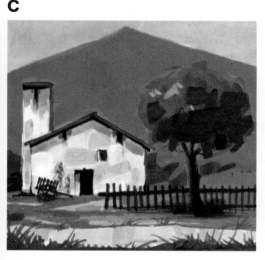

D

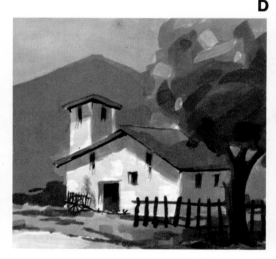

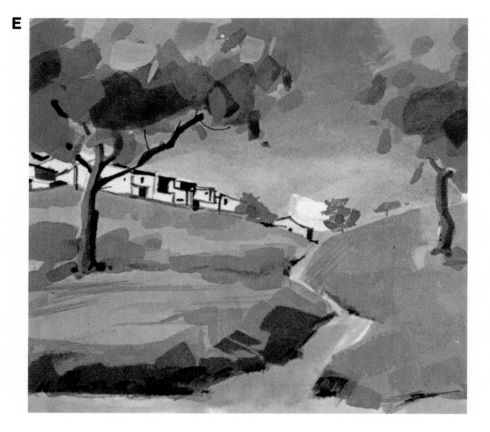

distracting. The tree sticks out awkwardly. The distant mountain makes a dull, uninspiring background. Its shape is a boring repetition of the house roof. But if we move nearer the tree and a little to the right, as in figure D, our new viewpoint gives a pleasant composition. It has greater diversity with unity. In this landscape, unity with diversity is found by viewing the subject from a better angle.

Figure E above includes two trees. This creates unnecessary emphasis on the right side of the picture. It detracts from the main theme, the group of buildings in the background. The dull foreground is given too much prominence. The result is lack of unity.

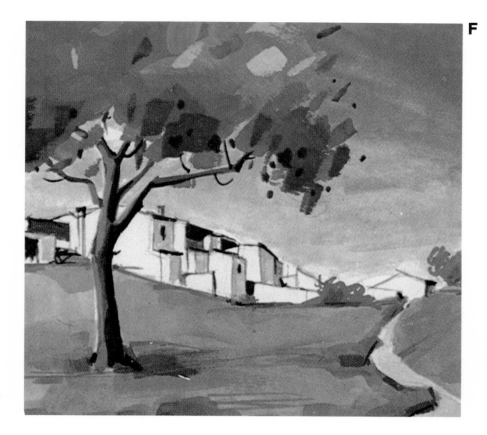

F

The next picture, figure F, is improved. We have confined ourselves to the principal theme, the houses in the background. The choice of a suitable viewpoint considerably improves the composition. We have focused attention on the area bordered by the tree on the left and the houses in the distance. This enlarges the subject and creates greater unity with diversity. We have produced a more effective composition.

It's not a difficult concept. You can see the importance of creating *unity with diversity* or *diversity with unity* in composition. Now let's go on to another part of this basic principle.

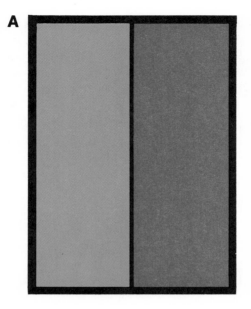

A

DIVIDING SPACES

The first problem in any artistic composition is to find one or more divisions or parts of the space.

Let's take a rectangle and divide it into two parts with one vertical line, as in figure A. This line becomes the axis from which the picture's important elements will be positioned. We draw the vertical

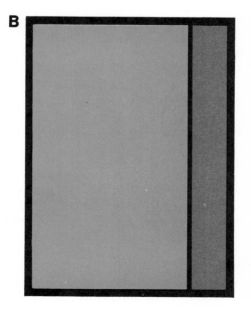

B

line in the middle of the space. But we get a dull, lifeless balance. There is no originality and none of the diversity so essential to good composition. If we shift this line too far to one side of the picture, as in figure B, the diversity is excessive. We get an imbalance between the blue and red spaces.

A better position for the dividing line is neither exactly in the middle nor too much to one side. It is usually located somewhere in between. The question is where? The following discussion gives us a method to answer that question.

Golden Section Principle

A common principle of ancient Greek art that is still valid today is the *Golden Section Principle.*

> **To divide a space according to the Golden Section Principle, the smaller part must have the same relation to the larger part as the larger part has to the whole.**

This principle of proportion appears in sculpture and architecture as well as painting. It is a basic guideline for the arts of many societies and ethnic groups. Expressed in numbers, the principle involves the ratio 3 to 5.

You can estimate by eye where the dividing point is with a little practice. But first let's understand how this works, using math.

We divide an 8" line into two unequal parts, one 3" long and one 5" long. The 3" part has the same proportion to the 5" part as the 5" part has to the whole 8". If you divide 5 by 8 for one section and 3 by 5 for the other, you get the same answer, 0.6.

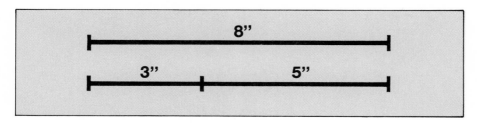

But don't worry about the mathematical calculations. For artistic use, just remember this number. *Whenever you need to find the Golden Section, multiply the length or height of your space by 0.6.* This will give you the point of division without any more calculations.

Consider this example.

Figure A below is a rectangle, 9" wide. If we multiply 9 x 0.6, we get 5.4. So, the two divisions of 9" by the Golden Section Principle will measure 5.4" and 3.6".

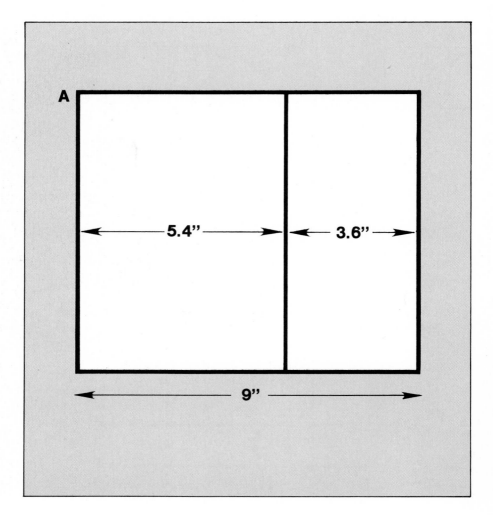

APPLYING THE PRINCIPLE

The Golden Section Principle can be applied to any width or height. You can use it to find a good place for a picture's center of interest. First multiply the height and then the width by 0.6. This ensures placing your main element in a good position, as shown in figure B and the Velazquez painting below.

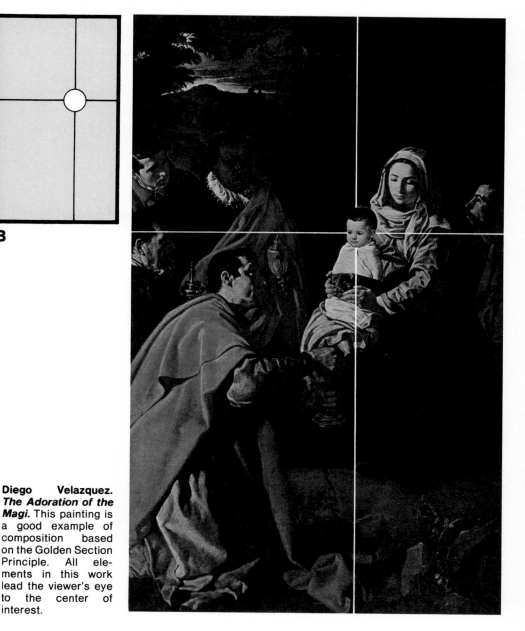

B

Diego Velazquez. *The Adoration of the Magi.* This painting is a good example of composition based on the Golden Section Principle. All elements in this work lead the viewer's eye to the center of interest.

A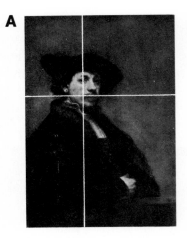

Rembrandt. *Self-Portrait.* The Golden Section Principle governs this portrait's composition. The painting is also a subtle example of overlapping, receding planes. See Arrangement of Shapes on the opposite page.

This principle can be applied to any kind of composition. It gives you the point for placing your center of interest in the composition, as shown in figures A, B and C.

But remember that *art is not an exact science.* If you analyze the composition of famous paintings you will sometimes find that the Golden Section Principle does not apply. That is because this principle is not the only guideline used in planning compositions.

There are other things to be considered. The Golden Section Principle can be modified by balance, your expression and your originality. But it is vital to know that this method exists and that it can be easily applied.

Even commercial art and advertisements can be designed according to the Golden Section Principle of composition.

ARRANGEMENT OF SHAPES

We have discussed one method of handling space: the Golden Section Principle. Now let's imagine some shapes. It does not matter what they are. We must use them to create a theme. We must move them, switch them and unite them.

First, examine Rembrandt's *Self-Portrait* on page 26. The parts of Rembrandt's face create a succession of planes. Nose, eyes, chin, ears and other elements recede from front to back. Figure D above illustrates the same principle. It gives an impression of unity. This technique is vital. *Overlapping different shapes to create a series of receding planes helps achieve unity.*

Overlapping two or more shapes to form receding planes is in agreement with the principle of unity with diversity. Figure E above shows a boring lack of unity as a result of missing overlap.

There are paintings in which the principle has been *ignored*, or even *contradicted*. This is the case in Francisco de Zurbaran's still life shown below.

Francisco de Zurbaran. *Still Life.* In art, every principle or so-called "rule" is broken occasionally. De Zurbaran has produced an interesting painting even though it violates the receding plane principle. He succeeds through color, form, lighting, contrast and variety of shape.

Symmetry

Symmetry is the equal balance of elements of a painting around a central point or axis. *Both sides more or less match*, or at least have great similarity. Symmetry produces beauty through balance and harmony. Landscapes, portraits, still lifes, advertisements, posters and illustrations can all be composed on a symmetrical or asymmetrical pattern. We'll discuss asymmetry later on page 33.

The human body is a good example of near-symmetry when viewed from the front in a stable position, as shown below.

The central axis may be real or imagined in a painting. There may be a central figure that serves as a real axis. Or the axis can be imaginary, with the picture's elements arranged around it symmetrically. This is shown in Paul Cézanne's *Card Players* or Fra Bartolommeo's *Madonna*, figures A and B on pages 30 and 31.

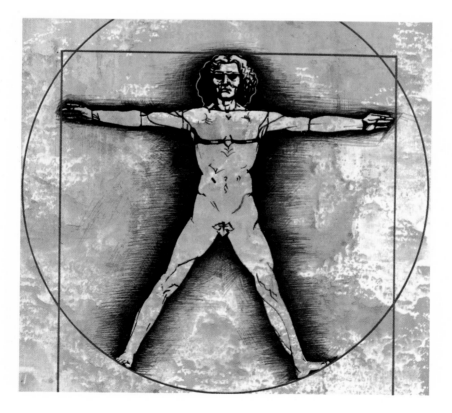

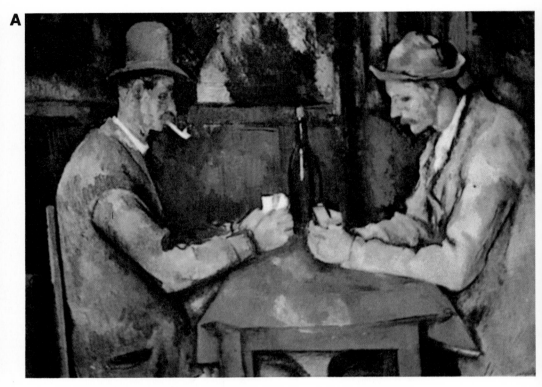

A

Paul Cézanne. *Card Players.* Two figures face off in flexible symmetry.

Symmetry has been a principle of artistic composition for centuries. Paintings with a religious theme are frequent examples. Symmetry is used to obtain a *balance* of elements. Study the compositions of Cézanne above and Bartolommeo opposite. Both paintings are examples of flexible symmetry, as described below.

Two Types of Symmetry—There are two types of symmetrical composition that we will study: *inflexible* and *flexible.*

Inflexible symmetry means that parts of a picture are arranged almost like mirror images of each other. They are composed around an axis that is nearly always a physical object. *Day,* by Ferdinand Hodler, is an example of inflexible symmetry, as shown on the opposite page.

With *flexible symmetry* we have a less rigid relation of the parts to one another.

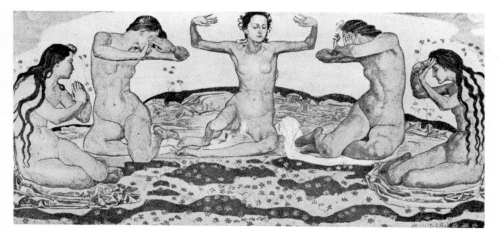

Ferdinand Hodler. *Day.* An example of inflexible symmetry.

Greater flexibility exists in the position of the figures or objects on each side of the central axis. This can be seen in Andrea del Sarto's *Virgin and Child with Saints.* There is symmetry here, but it is not mirror image.

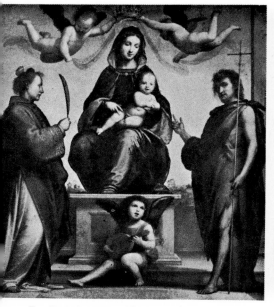

Fra Bartolommeo. *Madonna.* Another example of flexible symmetry.

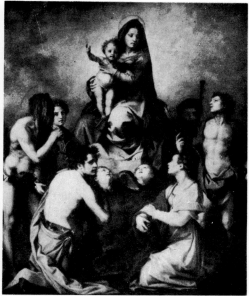

Andrea del Sarto. *Virgin and Child with Saints.* This painting is less rigid but still illustrates flexible symmetry.

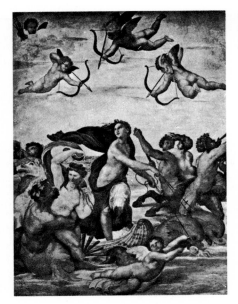

Raphael. *The Triumph of Galatea.* Similar shapes produce flexible symmetry.

Flexibility can also be developed by altering the positions and arrangement of a painting's elements. Raphael did this in *The Triumph of Galatea.* Flexible symmetry can exist where there are only *similar* shapes, or a balance of color values or lighting. This is illustrated in Sandro Botticelli's *The Birth of Venus,* shown on the next page.

These examples suggest that

Symmetry in composition can express ideas such as religion, solemnity, splendor, luxury, strength and passion.

The Greeks and Romans made wide use of symmetry in art. The Greeks introduced flexible symmetry and the idea of an imaginary central axis.

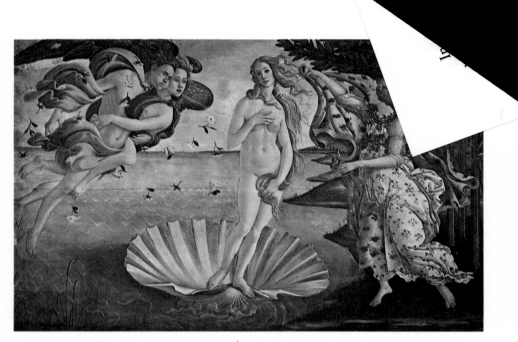

Sandro Botticelli. *The Birth of Venus.* There is diversity here along with flexible symmetry.

Asymmetry

Asymmetry is the opposite of symmetry. It is the lack of symmetry, the non-matching of one part with another in relation to a central axis.

> **Asymmetry is the arrangement of the elements of a picture without regard to equal balance. Some parts are balanced against others to obtain unity, but all are not balanced equally around a central point or axis.**

Let's return to our basic principle, *unity with diversity.* We know that symmetry is in harmony with the principle of unity in planning a composition. But we also know that it is difficult to obtain diversity when symmetry exists. The Greeks pondered this problem. Their attempts to disguise the matching of one part with another produced the idea of flexible symmetry.

asymmetrical composition, you have more freedom to use diversity at the expense of unity. But you must be careful. Your composition can become disorganized and chaotic. Every kind of composition works best when balance of masses is present.

BALANCE OF MASSES

We know there is a difference between symmetrical and asymmetrical composition. They are related to the *balance of masses*. Let's study ordinary weighing scales and Roman scales to understand these principles.

Ordinary scales have two dishes of equal weight, set an equal distance from a central upright, as shown in figure A. They are a good example of symmetry. Their balance is based on the principle of matching weights. Weights will balance under two conditions—when the weights are exactly the same, and when they are the same distance from the point of balance, as in figure B. The same principle results in perfect symmetry when applied to composition. This is illustrated in figure C.

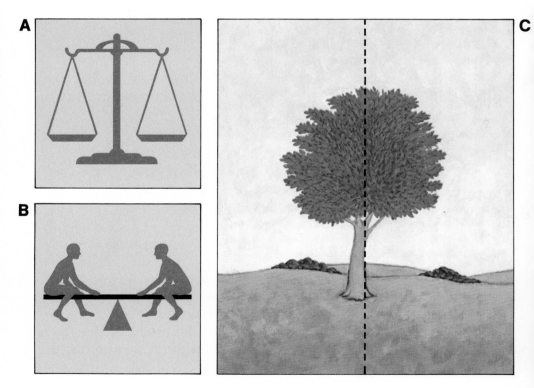

The Romans used a scale of the type illustrated in figure D. Unequal weights at unequal distances from the center give an asymmetrical balance, as shown in figures D and E. If we place unequal weights opposite each other we must compensate by putting the heavier weight nearer the point of balance. The lighter weight must be farther away. The same principle applied to composition produces balance in an asymmetrical composition, figure F.

But in painting and drawing we are working with *masses*, not weights. To understand the term masses we must first understand *line* and *value*. Figure G on page 36 illustrates what *line* means. It is the basic element of a drawing. Line can be used to define a shape or object.

Value is the *relative lightness or darkness of a color*. It is the intensity of light or shade. In figure H on page 36, value gives *weight* and *volume* to the subject.

When we speak of *mass* in relation to balance, we are referring to *blocks of light and shadow*, without details.

How you position the areas of different value defines the mass, as shown in figure I. *Masses help determine the composition of a work.*

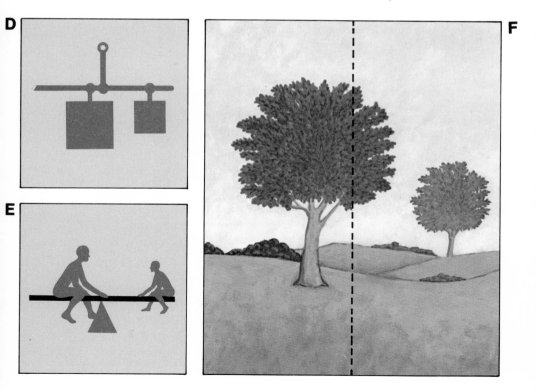

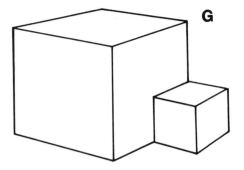

Line is a fundamental tool of the artist. It can be simple as at right or complex, such as wavy or irregular lines. Here it outlines shape.

G

H

I

Value is the lightness or darkness of a color, especially as compared to adjacent colors.

Mass refers to blocks of light and shadow. Mass can be seen easily if you squint your eyes and look at the subject.

SIMPLIFYING MASSES

The painting, *St. Anthony Abbot and St. Paul the Hermit* by Diego Velazquez, is simplified into masses on the opposite page. The areas of light value are light gray. They separate darker values and eliminate details. These are the major blocks of mass.

Keep in mind the definition of mass and the examples based on scales and weight. Then we can understand the following guidelines:

- **Good composition is achieved by balancing some masses against others.**

- **Balance comes from a combination of the following factors:**

 Size of masses in relation to others.

 Distance between masses.

 Value of masses in relation to others.

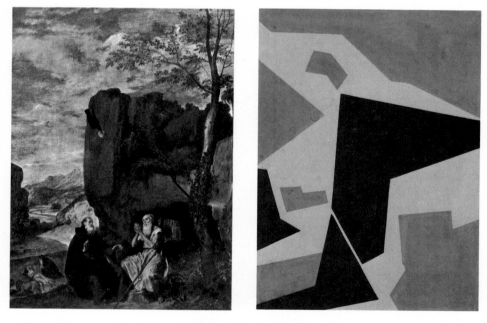

Diego Velazquez. *St. Anthony Abbot and St. Paul the Hermit.* Squint your eyes and you can see the masses—or blocks of light and shade—in the painting on the left. These blocks are simplified at right. Arranging the masses of a subject is a key part of composing a painting.

A

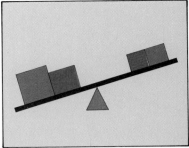

This illustration shows *imbalance*. There is too much mass on the left side.

Figure A above shows a landscape containing a clump of trees and a house. Opposite the dark mass of trees on the left is a smaller mass, a group of distant trees and the house.

The top illustration is an example of imbalance. The heavy mass is too obtrusive. It attracts visual interest from the smaller mass. The seesaw alongside shows this imbalance.

In figure B below we have shifted the large mass toward the center and altered the values of the trees. This gives a more even balance between one side and the other.

B

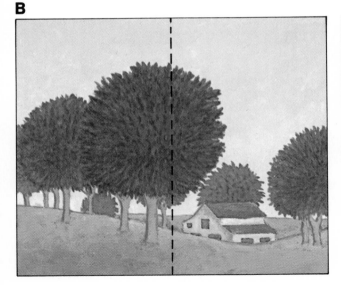

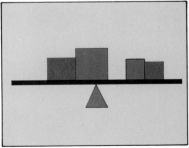

This illustration is more *balanced*. The mass has been shifted toward the center.

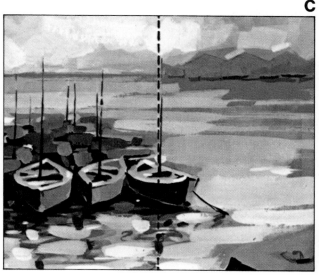

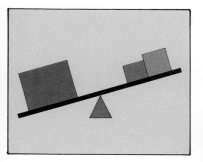

The heavy mass of boats on the left makes this illustration appear imbalanced.

In figure C above, we have a seascape with an imbalanced composition. The mass of boats on the left and the pier in the right foreground are out of balance. Part of the background land area on the right shows only as a light-colored mass. It fails to offset the boats.

To obtain a proper balance we must do two things. First, reduce the main mass of boats on the left, as in figure D. Next, increase the size of the land mass on the right. Its size and prominence give greater weight on the right side of the picture. This creates a more balanced composition.

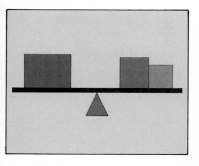

The boats are reduced and the land mass is larger and more prominent. Now the illustration is balanced.

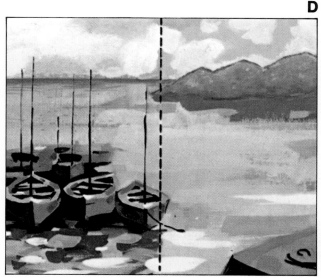

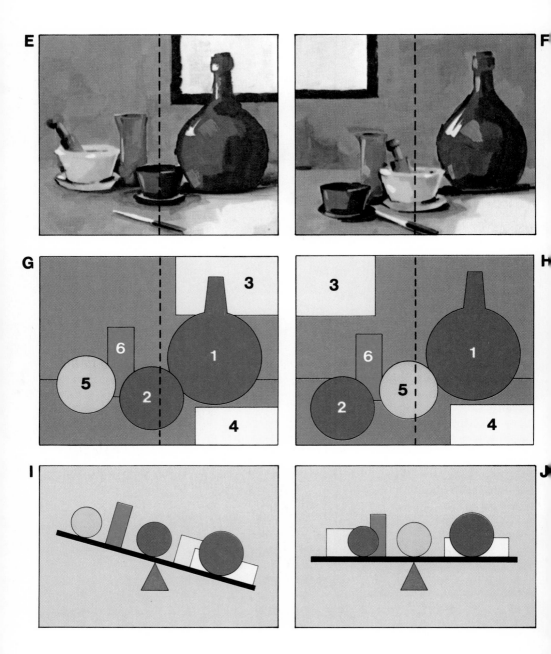

Figure E above shows a more complex and detailed example of balancing masses. It's a still life with a bottle, bowl, vase, knife and mortar displayed on a table against a wall with a window. Note that on the right in figure G, masses are in parts 1, 3 and 4. On the left, we have the bowl, 2, the mortar, 5, and the vase, 6. This picture is not balanced.

Now look at the same objects placed in a more balanc
ment, figure F. Notice in figure H how the dark mass 1 is
and strengthened by 6. Light masses 3 and 4 are placed in
opposite dark corners, counteracting the dark and bal
another. Finally, note the position of 5, the light mass of
Now centered, it is an intermediary for the eye between the light and
dark shapes. We have obtained diversity with unity.

The seesaw diagrams, figures I and J, clarify the examples by
demonstrating contrasting weights.

Form

In a research test, a number of people were shown three collections
of shapes. They were asked which they liked best. One was a group of
geometric shapes, including a rectangle, a right-angle triangle, an
equilateral triangle, a circle or ellipse and a square. Another group
consisted of natural shapes, including the silhouettes of two leaves,
the profile of a man's head, a butterfly and a hand. The third group
was made up of abstract shapes. These are illustrated on page 42.

ost of the people said that the best, most eye-catching, remarkable and easily remembered shapes were, in order:

1. Geometric
2. Natural
3. Abstract

This preference for simplicity of form parallels the methods of composition used by great artists for centuries. These survey results can serve as a guide to your painting. You may want to give preference to geometric and natural shapes in choosing subjects and compositions.

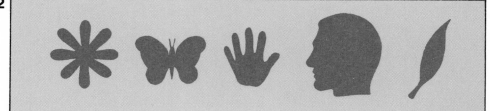

Traditional Types of Composition _____

Certain compositional schemes have become associated with various schools of art. The use of geometric forms as a basis for composition can be clearly seen in many classical and contemporary works.

RECTANGLE

Composition is not always based on a single rectangle, but rather on several rectangles within a picture. Sometimes rectangles determine the major composition, as in Cézanne's *Portrait of Achille.* Sometimes they are superimposed or juxtaposed, as in Pablo Picasso's *Violin and Vase.* Single or multiple rectangular construction—the repetition of a single element or figure in a picture—is fashionable in contemporary art. The work of Mondrian is typical of this. The rectangle was also the basic form of the Cubist art movement.

Below is a sketch after **Paul Cézanne's** *Portrait of Achille,* which shows vertical, rectangular composition.

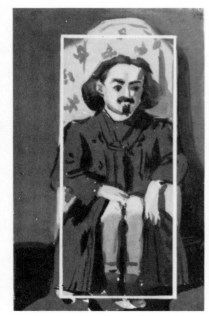

This sketch is after **Pablo Picasso's** *Violin and Vase.* It shows the artist's use of rectangles throughout the painting.

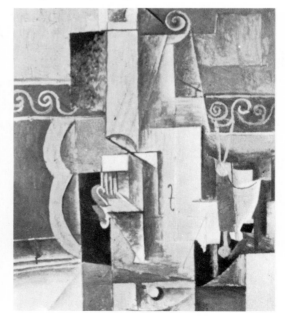

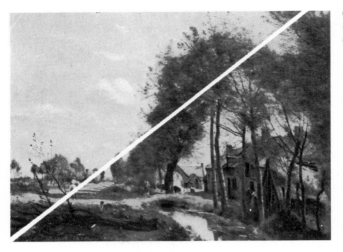

RIGHT-ANGLE TRIANGLE

Basing composition on a right-angle triangle is traditional in art. Painters of all periods and styles have used it. Sometimes the picture is divided diagonally by light and shade. This is shown in *The Sin-Le-Noble Road near Dovai* by Camille Corot. In other paintings the triangular composition is camouflaged by other shapes and forms as in Titian's *Noli me Tangere* or Paolo Veronese's *Calvary.*

Titian. *Noli me Tangere.* Paolo Veronese. *Calvary.*

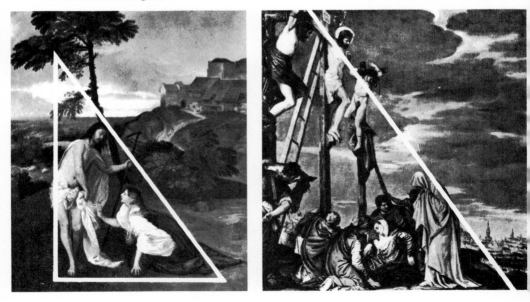

EQUILATERAL TRIANGLE OR PYRAMID

Equally traditional and closely related to symmetrical composition is the pyramid. It was often used in figure paintings of the Renaissance, as shown in Titian's *Virgin of the Cherries.* It has continued to be used in portraits, even by modern Masters. Sometimes the shape, an equilateral triangle or pyramid, is inverted, as in Velazquez' *Coronation of the Virgin.*

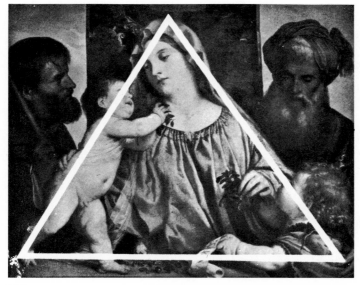

Titian.
Virgin of the Cherries.

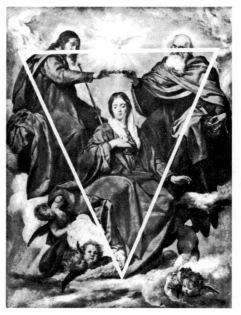

Diego Velazquez. *Coronation of the Virgin.*

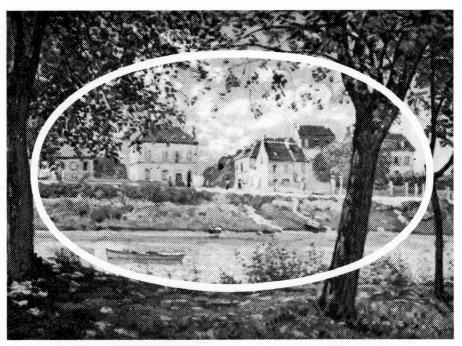

Alfred Sisley. *Village on the Banks of the Seine.*

Henri Rousseau. *The Way Out of the Wood.*

ELLIPSE

The use of an ellipse as a compositional form is seen less frequently than other shapes. You can find a few examples in 19th century Romantic art that were influenced by the vogue of that period. Work was often marked out in ovals. The examples I have found are primarily landscapes, such as those shown above.

TYPOGRAPHICAL

Composing pictures in the shapes of capital letters such as L, J, S, Z, C or Y offers many geometric possibilities. These are based on

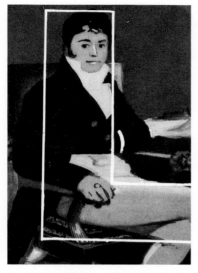

A sketch after **Jean Auguste Dominique Ingres'** *Portrait of F. Riviere.*

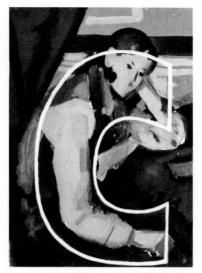

A sketch after **Paul Cézanne's** *Young Man in Red Waistcoat.*

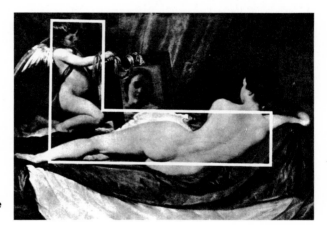

Diego Velazquez. *The Toilet of Venus.*

combinations of rectangles, angles and triangles. We see this type of composition used—perhaps subconsciously—in many famous works. The L-shape, in particular, is traditional and classic. It has been used in thousands of compositions throughout the ages.

The paintings above are examples of letter shapes as compositions. These shapes are also used in commercial art, especially in advertisements, brochures and posters.

These traditional forms of composition give us broad guidelines for planning and arranging pictures. They are flexible enough to give unity without being restricted by rigid regulations.

47

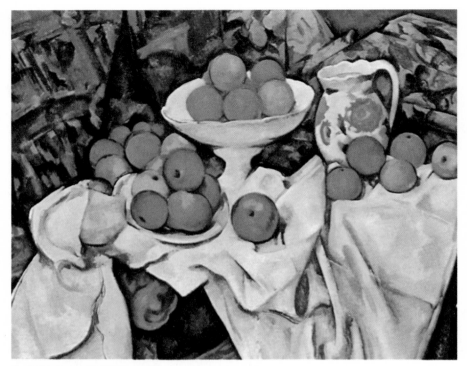

Paul Cézanne. *Still Life with Sugar Bowl* (detail).

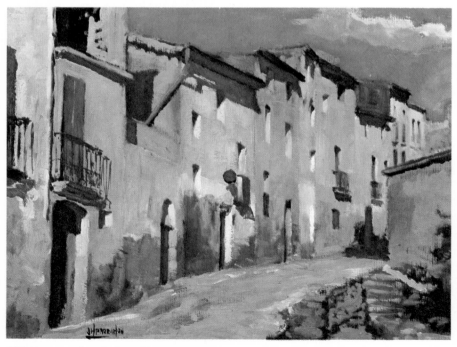

J.M. Parramon's painting of a village street.

DIVERSITY IN COMPOSITION 2

Echoes
Contrast
Drama in Painting
Expression through Texture
Originality in Composition
Center of Interest
Rhythm

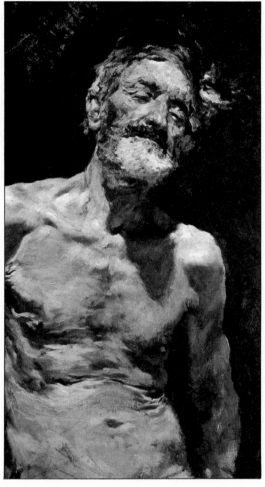

Mariano Fortuny. *Old Man Naked in the Sun* (detail).

Diversity with unity means *variety with order.* This can be achieved by repetition and reflection of colors, values, lines and shapes.

Echoes

Repetition and rhythm have similar meanings for the artist. Now let's introduce the term *echoing.* I prefer this term because it is more general and less restricting than repetition.

To get an echo effect, we create likenesses, weaving them through the picture. These repeat the feelings of color, form and style within a picture. This is often called the *Principle of Repetition*. With it we can obtain greater *harmony* in a composition and use diversity better.

Let's study some famous works of art to better understand this idea.

One of the best examples of echoes is seen in Vincent Van Gogh's self-portrait on the opposite page. It shows Van Gogh when he was 36. Let's examine the way he has echoed color, volume, form method and style.

Color—Van Gogh's self-portrait is subtly dominated by the pale green of the background. He painted the highlights of the face with green and used it again in the shaded areas. We can pick out a slightly deeper shade of green in the hair and beard.

Look at the lips. What color are they? Green. This painting shows Van Gogh's mastery of deliberate echoing and reflection of color.

Volume—In all Van Gogh's paintings you can see his tendency to paint things as one-dimensional. The two-dimensional effect of light and shade is disregarded.

The self-portrait shows this clearly. Van Gogh has treated background, clothes, even his head, as if they were flat planes lighted from front center. He avoids shading and strong contrasts of value and color. Instead, he floods all surfaces with color and light. This technique is fundamental to the picture. It creates a distinctive style that is repeated in all of Van Gogh's work.

Form—Van Gogh has created echoes of folds in clothing by curved brushstrokes. He has drawn spirals that are repeated almost obsessively throughout. Notice how deliberate the spirals and curves are. They are not just in the background, but also in the clothes. They even occur in some parts of the head.

Method and Style—Van Gogh uses heavy lines and an unusual thickness of paint. He uses dark strokes to emphasize features, outlining boldly and filling in as needed. His technique depends on drawing as the basis for a painting. His unique and repetitive style can be instantly identified.

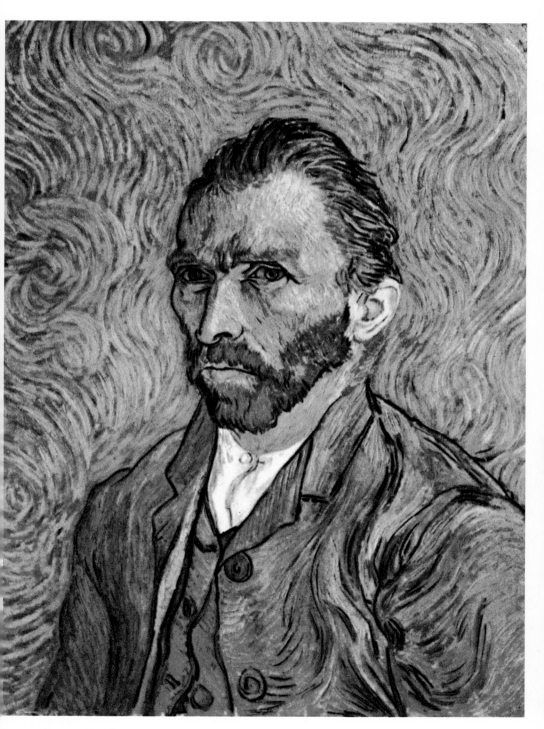

Vincent Van Gogh. *Self-Portrait.* This famous painting by the Master is an excellent example of *echoes* of color, volume, form, method and style.

El Greco. *Assumption.* This artist's elongated figures—especially the arms and legs—are an example of the *echo* technique. Highlights on all the forms are part of El Greco's method of repetition in this unusually vertical work.

This echo technique is not limited to Van Gogh's work. It has been used by artists with widely varying backgrounds and styles. Study the paintings opposite and below. El Greco, who painted in the 17th century, and Jacques Villon, who painted in the 20th century, use visual repetition. Notice the examples of echoing and reflection in their work. They have based their work on the Principle of Repetition.

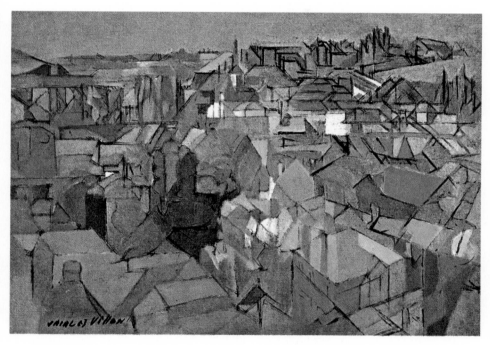

Jacques Villon. *The Little City.* This brightly painted work is full of echoes in form and color.

Contrast

Contrast is a basic and practical method of creating interest, excitement and diversity with unity.

Contrast in composition has a specific meaning. Let's discuss contrasts of light, color and value, shape and position, and size.

Light, Color and Value—Any famous painting can show us how to create contrasts of light, color and value. Let's analyze two paintings

Joaquin Sorolla. *Boy Playing in the Sea* (detail). This painting offers an excellent lesson in unusual composition. The boy is positioned at the top to allow room for reflections and colors on the water. There is an important use of contrast here. The blue-green paint is adjacent to orange. These are almost *complementary* colors, colors that are opposites on the color wheel. They provide maximum color contrast. Sorolla has created *diversity* with this technique.

that illustrate contrast: *Boy Playing in the Sea* by Joaquin Sorolla, shown above, and *Madonna and Child* by Caravaggio on the opposite page.

Sorolla, who painted during the 19th century, was known for his color effects. In *Boy Playing in the Sea* he creates color contrast be-

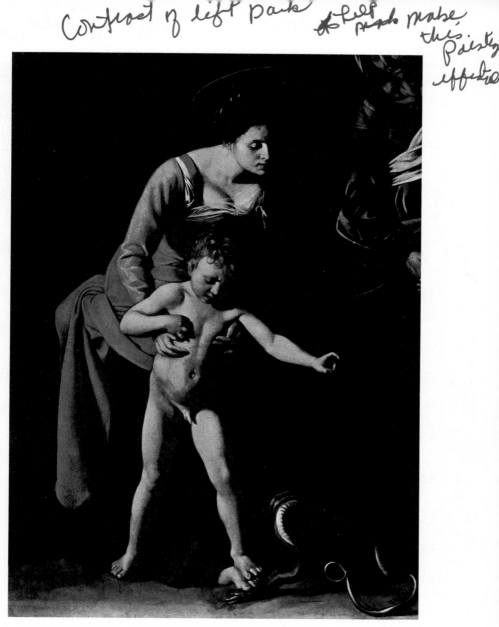

Caravaggio. *Madonna and Child.* Contrast of light and dark plays a major role in this painting's effectiveness. The lighted figures on a dark background create viewer interest.

tween flesh tints of the figure and the strong blue of the sea. These two colors are almost complementary.

Caravaggio was a Renaissance painter who had a complete grasp of the importance of light. He knew light was a basic element in composition. He creates volume, strength and viewer interest by deftly using contrast in value.

Shape and Position—An artist can contrast the vertical with the horizontal and circles with squares. There are many contrasting shapes that can attract attention and arouse interest. Let's again use paintings of the Masters as examples.

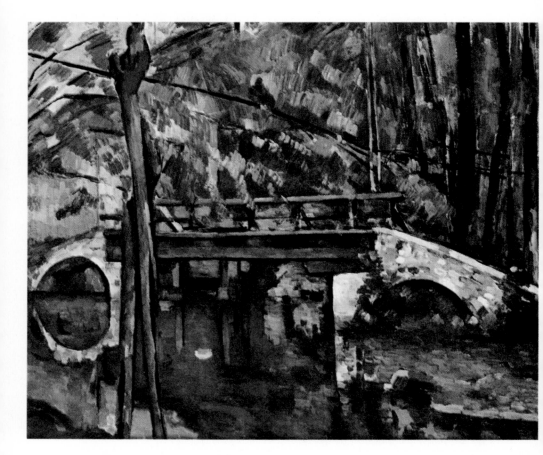

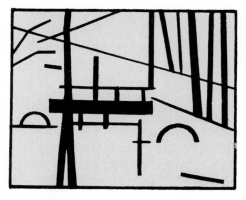

Paul Cézanne. *The Bridge at Maincy.* Contrasts in Cézanne's painting are those of vertical lines or shapes against horizontals and curves. The overlapping lines create unity with diversity.

Cézanne contrasts shapes in his painting *The Bridge at Maincy* shown on the opposite page. The diagram below the painting highlights the areas of contrast. There is contrast between vertical lines of tree trunks and horizontal, slanting, curved lines of the bridge.

Position is important. Look at the contrasts made by the lines. They are in *tension* or *conflict* with one another because of their relative positions.

Study the contrast of shapes in Alfred Sisley's *The Banks of the Seine*. The diagram highlights the contrast. Circular clouds, horizontal boats and horizon line are set against the vertical trees. This is a perfect example of the contrast of opposing shapes.

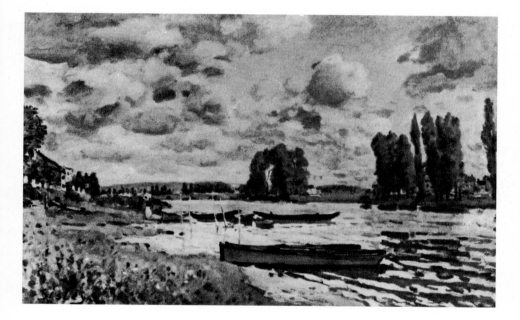

Alfred Sisley. ***The Banks of the Seine.*** Sisley's painting shows contrast of vertical, horizontal and circular shapes in a manner similar to Cézanne's work on the opposite page.

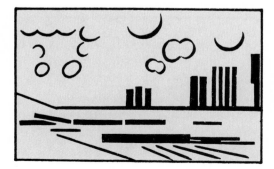

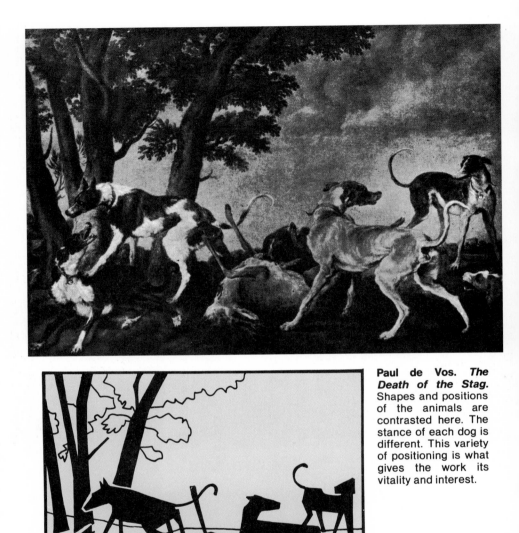

Paul de Vos. *The Death of the Stag.* Shapes and positions of the animals are contrasted here. The stance of each dog is different. This variety of positioning is what gives the work its vitality and interest.

Now look at *The Death of the Stag*, by Flemish painter Paul de Vos. This is another good example of contrasting shapes and positions. Note the stance of each dog and the direction of each head. All are different.

This is not by chance. It was the deliberate intention of the artist to create these contrasts to achieve diversity. The picture has great vari-

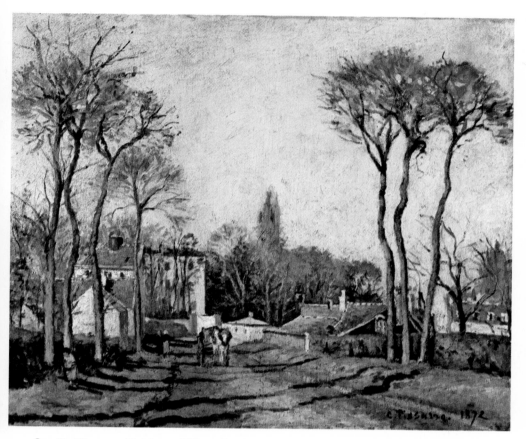

Camille Pissarro. *Entrèe au Village.* The great height of the trees in Pissarro's painting creates strong contrast with the comparatively small human figures.

ety. It seems to have movement and vitality. Yet it is ordered, controlled by its unity, in a carefully designed L-shape composition. There is a deliberate overlapping of different shapes. This creates a series of receding planes and illusion of depth. It is a good example of balance.

Size—Contrasting the size of figures in a picture captures attention and creates diversity. In Camille Pissarro's *Entrée au Village*, the artist draws our attention to the tall trees in the foreground. He does this by placing two figures and a wagon beside them. This creates contrast and variety. It also introduces human interest.

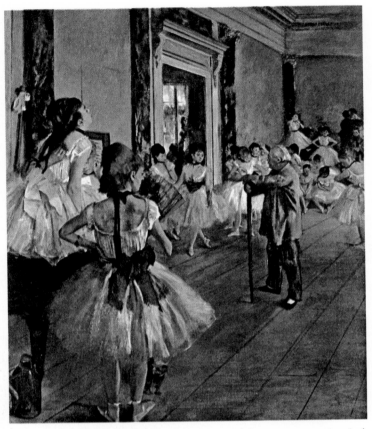

Edgar Degas. *The Dancing Class.* Foreground dancers are contrasted in size with other figures. This gives the painting a feeling of depth and creates variety and interest.

In Edgar Degas' *The Dancing Class* the artist has aroused our interest by magnifying the two foreground figures. This is done by matching them against the smaller, detailed figures farther back. Everything converges on the center of interest, the dancing master. He is alone in the center of the floor, contrasted by form and color.

When you're planning a composition for a landscape, house, village or figure, remember contrast and its importance. Contrast can be produced simply by painting a man and a woman instead of two people of the same sex.

When you paint a street full of straight lines or angles in houses, include some foliage. These will contrast with the harsh geometrical shapes behind them. Remember the contrast of light and shade, of size and emphasis, of foreground in relation to the rest of the picture.

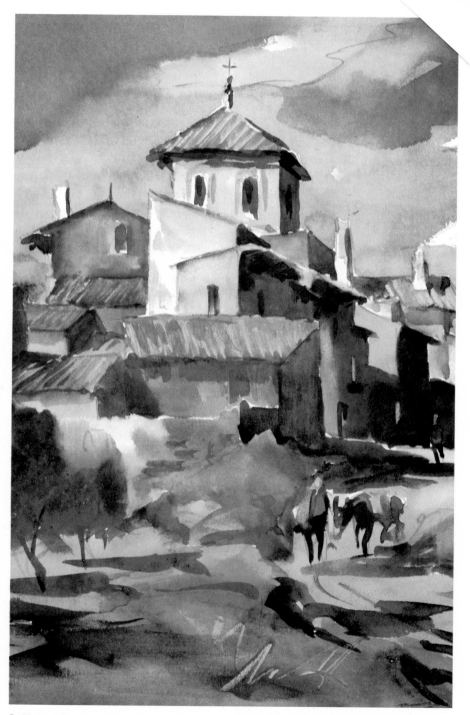

Guillermo Fresquet. This detail from a watercolor of a village scene shows the artist's technique of contrasting values and colors. Lighted shapes against areas in shadow are emphasized to add drama.

Drama in Painting

Most famous works of art have something dramatic about them. Examine your subject for its dramatic possibilities. But *never force drama.* Don't paint melodrama and tragedy into everything.

You can emphasize and enhance your painting in a dramatic way whatever its theme. Never think that dramatic expression can only be physical or human. Drama doesn't just mean smiling, weeping or anger. *Light* can be a means of expressing drama. Light can express decision or portray a state of mind.

> **Add drama to a painting by arousing interest through emphasis of (1) viewpoint and size of figures, (2) light, color and value, (3) form and human interest.**

Viewpoint and Size—A camera can take a good close-up portrait in which the head and face become the photograph's main theme. Yet amateurs take snapshots or portraits that show an empty space with a small figure in the middle. This is because the amateur, in his ignorance, fails to pursue *drama of expression.*

This brings us to a basic technique: *Draw near without fear!*

When you plan a composition, get *closer* to your subject. Portray the *head and shoulders only,* instead of the whole body.

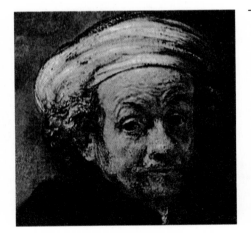

Rembrandt. *Self-Portrait: The Painter in Disguise* (detail). Rembrandt illustrates a point about composition in this self-portrait: Get *close* to the subject. *Draw near without fear!*

When you begin a still life, see how large you can paint it within the dimensions of the surface. Make it larger, more detailed. How else can you dramatize the subject? How else can you see the velvety skin of the peach, the shimmering feathers of the wild duck?

Imagine how a mediocre painter would treat themes like those below. Through inexperience he would include too much empty space in the painting.

The illustrations on the left show the dull, amateurish way to compose paintings. Those on the right emphasize the *drama* of the subjects by changing the viewpoint or size.

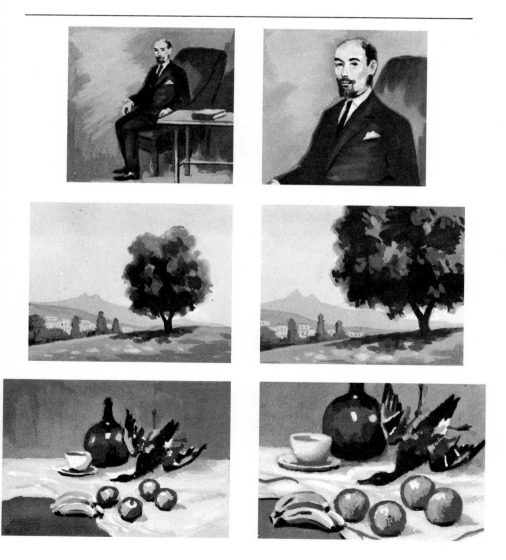

Composition
With a Viewfinder

It is helpful to plan your composition before you begin. You can use a simple viewfinder made of cardboard like the one shown above. It should have a picture area of about 4x6''. Hold it at eye level and look through it at your subject. Move it toward or away from the subject. Shift it up and down and to one side and the other. This will help you choose a good viewpoint and composition.

A

Cut out two L-shaped pieces of cardboard.

B

Place one over the other. You can alter the shape of the opening from horizontal to vertical.

C

Look at your subject through the opening from your painting location. Adjust the opening until your subject is composed.

D

Paperclip the viewfinder in the chosen proportions. Then you can review the composition as needed.

A similar device for viewfinding can be made with two right-angle frames made from cardboard. Cut them out as shown in figure A. Place one over the other, so you can make the opening larger or smaller as shown in figure B. Then look at your subject through this frame, standing where you intend to paint. Adjust the size until you get the most appropriate composition, as in figure C. Secure the two pieces with paperclips as shown in figure D. This will enable you to repeatedly look at your composition in framed position.

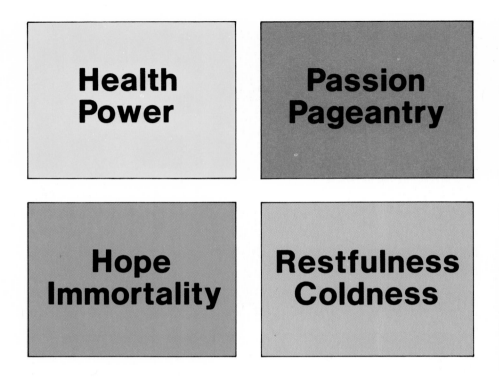

Health Power	Passion Pageantry
Hope Immortality	Restfulness Coldness

Light, Color and Value—Light and color are both powerful means of expression in painting.

Light can convey feelings of joy or sadness, hardness or softness, movement or stillness. There are several kinds of light. There is *direct light*, such as sunlight or electric light, that illuminates the subject. There is the *diffused light* of an overcast day or the reflection of artificial light. Light can express ideas, feelings and states of mind.

Color expresses feelings in a definite way. Studies on the psychological effects of color have shown that yellow can convey health and power. Red can convey passion and pageantry. Green is a symbol of hope and immortality. Blue is associated with restfulness and coldness.

Value of colors can be expressive. Value can create a sense of delicacy and quietness, or toughness, energy and dynamism. Its effect depends on how it is used: diffused or definite, hard or soft.

The artist's task is to use light, color and value effectively to create drama, emphasize the subject and give the painting a sense of *vitality*.

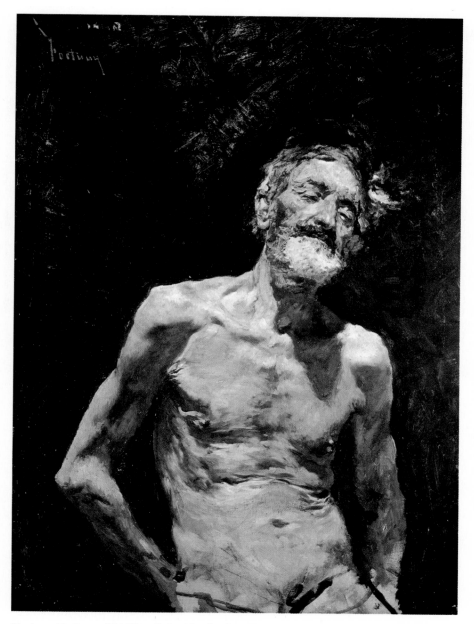

Mariano Fortuny. *Old Man Naked in the Sun.* This painting is an excellent example of contrast and drama. The man's bony, wrinkled body—dramatized by his unusual stance and the intense lighting from above—is contrasted against a dark background. These techniques convey a sense of weariness and old age.

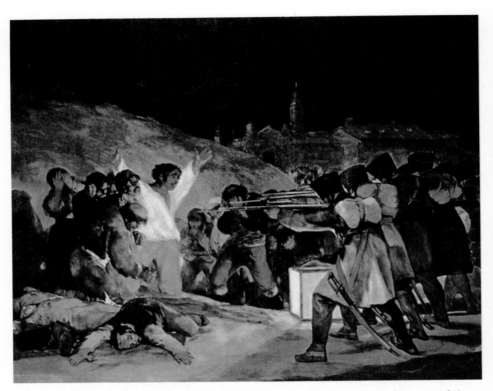

Franciso Goya. *The Third of May.* Forms of the peasants and soldiers are part of the drama in Goya's painting. But the bright, low lighting of the soldiers' lantern is the key element of drama in this work.

Form—Many of the Masters used *distortion* of form to dramatize a subject. Thin, elongated, stretched-out forms give the impression of idealism or the supernatural. Stunted and thick forms and figures convey materialism, earthiness or vulgarity.

Cervantes described the characters of Don Quixote and Sancho Panza this way. Gustav Dore portrayed the characters perfectly in his famous illustrations for *Don Quixote*. He created two different types whose portraits told much about their characters, as shown on the opposite page.

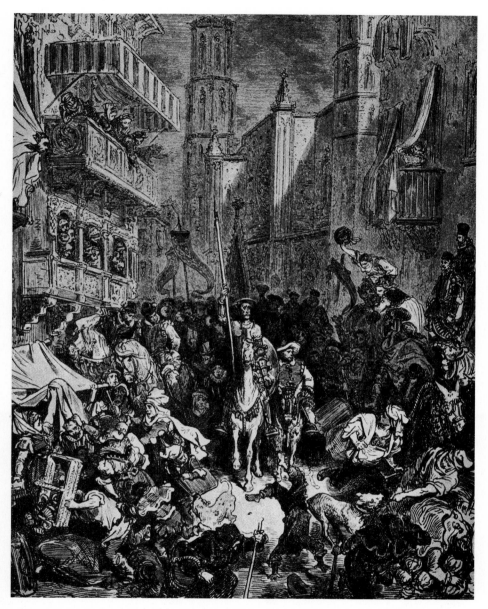

Gustav Dore. The characters of Don Quixote and Sancho Panza are dramatic figures because their form has been emphasized. Quixote is tall and thin. Panza is short, squat and earthy.

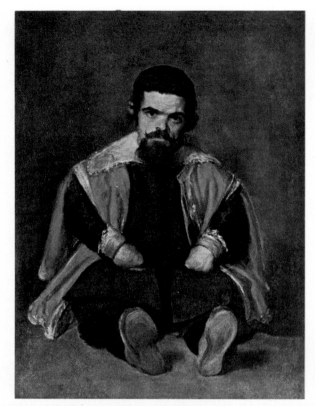

Diego Velazquez. *The Court Dwarf: Don Sebastian de Morra.* The frontal view of the subject and fully visible arms and legs dramatize the form of this figure.

Francisco Goya. *Two Old Men Eating Porridge.* These grotesque figures below show how dramatized forms can create feeling or atmosphere in painting.

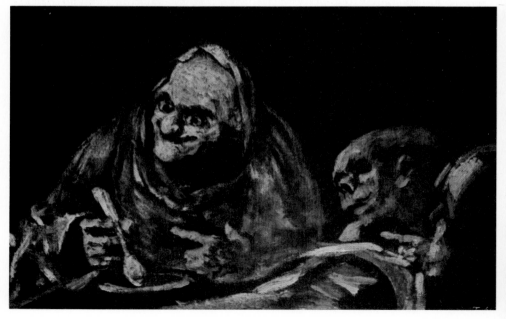

Look at *The Court Dwarf: Don Sebastian de Morra* by Velazquez and *Two Old Men Eating Porridge* by Francisco Goya. These paintings exemplify the artists' skill at creating character studies through dramatized form.

Human Interest—There's little that will interest one human as much as another human. An artist must use all dramatic possibilities when he paints a picture with people in it. Dramatization of this kind can give great meaning when based on real-life situations. The illustrations that follow are examples of dramatization through human interest.

Edwin Landseer. *Lament for His Master.* There is tenderness, sadness and human interest in this painting. These qualities come from the carefully planned treatment of the dog and casket.

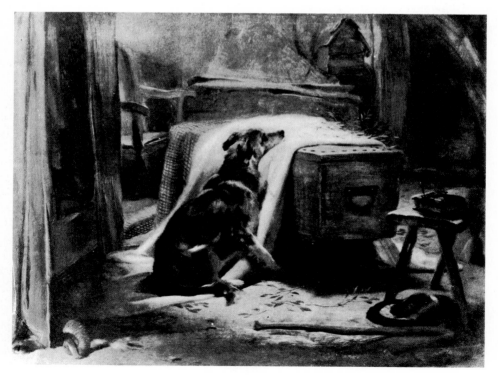

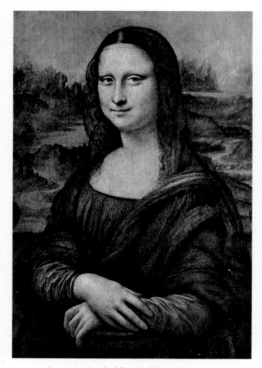

Leonardo da Vinci. *Mona Lisa.*

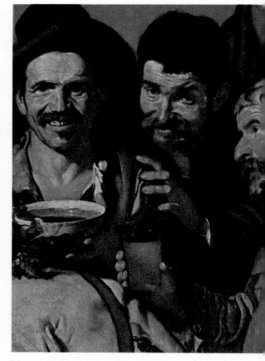

Diego Velazquez. *The Drinkers* (detail).

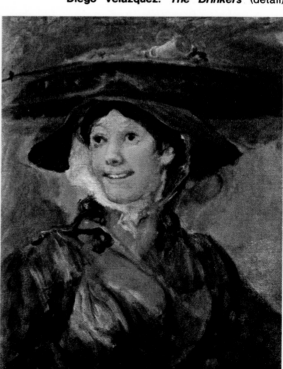

Mona Lisa's expression and famous smile have captured viewers for centuries. The painting may be one of art history's most famous in terms of human interest. In ***The Drinkers,*** there is a feeling of happy camaraderie. This kind of scene is hard for a viewer to ignore. ***The Prawn-Seller*** generates human interest by means of a gay, smiling face. The painting seems spontaneous and full of life.

William Hogarth.
The Prawn-Seller.

EXPRESSION THROUGH TEXTURE

Diversity with unity can be achieved by using special techniques. One technique is *texture*. In *Absinthe*, Degas used turpentine and a thin coat of paint to emphasize the canvas' surface. He merely tinged the canvas with color, using oils as if they were watercolors.

Claude Monet used an opposite method—painting the canvas thickly. It almost seems to portray the subject in three dimensions. Look at *Rouen Cathedral in Full Sunlight* on page 74. Techniques such as these arouse interest through the effects they create.

The pioneers of abstract art placed great emphasis on texture. They based everything on the *feel* of a picture.

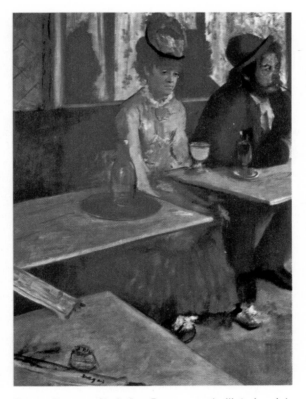

Edgar Degas. *Absinthe.* Degas used diluted paint, barely covering the canvas with pigment. This technique allows the texture of canvas to show through, influencing the painting's appearance.

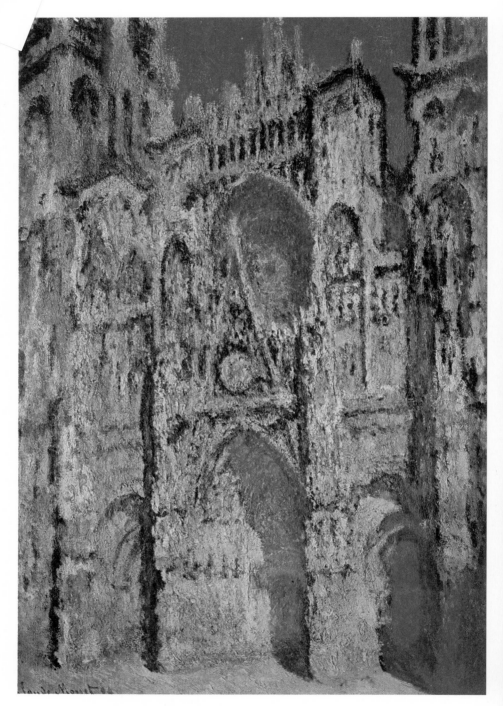

Claude Monet. *Rouen Cathedral in Full Sunlight.* Monet used thick oil paints and applied them in a technique that portrays his subject almost in *relief, or three dimensions.* The method is an example of texture carried to a successful extreme.

ORIGINALITY IN COMPOSITION

An original composition offers a pleasing arrangement and combination of space, form and color. But what is *originality?*

> **To be original is to be unique, to start fresh, to create something without copying anyone or anything.**

Originality can't be taught. There is no book of rules for originality. But an artist must not rely on a single technique. He must work steadily, searching for originality and learning more about his art. He must try to be *himself.*

One method to develop originality is to first study and even imitate the *methods* of the Masters. The artist should use imitation *only* to develop his own style. He should not copy other work excessively. Too much copying can actually stifle originality.

The following guidelines will help you be more creative:

> **Familiarize yourself with the principles of composition.**
>
> **Follow the techniques of the Masters in your own work.**
>
> **Study the Masters' teachings. Adapt them to your own needs. Search for a new approach.**
>
> **Don't let success or failure hold you back. Always renew your efforts.**

Let's examine works by two masters of composition, Andre Derain and Cézanne, shown on the following pages. The diagrams beside the finished works show the compositions in simplified form. Notice how the different styles of these artists depend on similar compositions.

tings on pages 76 through 79 are good examples of origi-
landscape composition. The first painting, Derain's *View of
es*, demonstrates the following principle for dealing with
ounds:

**Always distinguish the foreground by
size and value from more distant parts.**

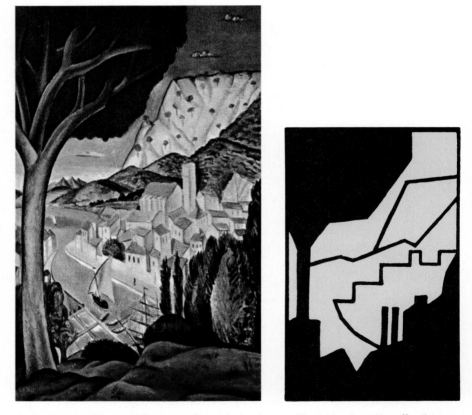

Andre Derain. *View of Martigues.* Derain's landscape illustrates how the effective use
of large, dark objects in the foreground distinguishes them from more distant parts of the
scene.

Compositions that follow this principle have their interest practically assured. A prominent foreground painted in this manner is one step toward obtaining unity. It is difficult to depart from the principle and still achieve unity.

Derain creates an original composition in his picture *Trees*, below. This is an imaginary landscape that he painted in his studio. It was done as an exercise in composition. Note the carefully planned positions and shapes of the trees. Look at the shapes formed by the tree trunks crossing each other in receding planes. There is a balance of masses in the symmetrically flexible composition.

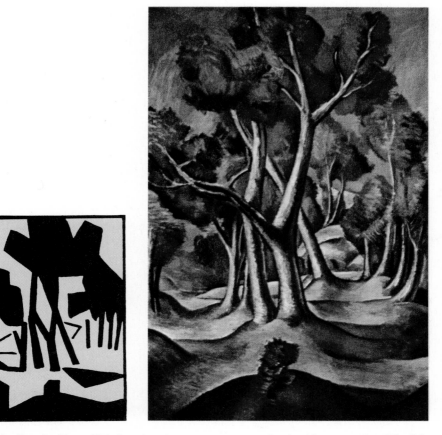

Andre Derain. *Trees.* This imaginary scene uses an emphasized foreground and flexible symmetry to convey the feeling of a quiet wooded area.

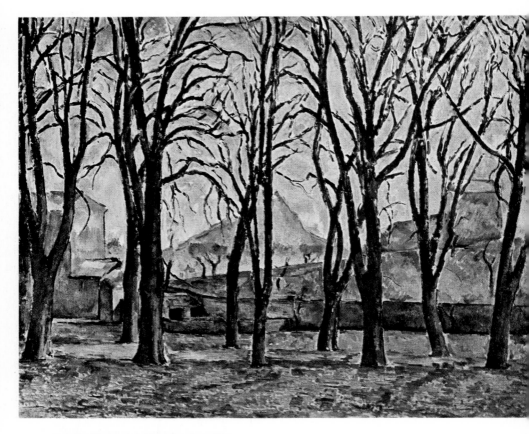

Paul Cézanne. *Snow at Fontainebleu.* Cézanne was a leader and a teacher through his original compositions. In this painting, his foreground is not treated with great importance as in Derain's works on pages 76 and 77. But the foreground here still leads the eye into the background.

This kind of originality in composition peaks with Cézanne. His bold and novel compositions were lessons for many painters. In the next two pictures you can see evidence of Cézanne's individuality. In *Snow at Fontainebleu*, Cézanne was not able to depart completely from

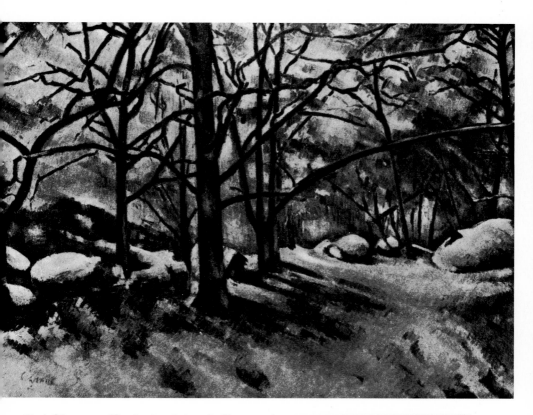

Paul Cézanne. *Chestnuts at Jas-de-Boussan in Winter.* Traditional practices have been ignored in this work. Cézanne has created a highly original composition with an unusual handling of foreground. The stately row of trees and landscape beyond invite the viewer to ponder the scene.

the idea of foreground importance. In *Chestnuts at Jas-de-Boussan in Winter*, the foreground principle is cast aside. Cézanne has achieved a brilliant and original composition. It has unity with diversity even though the foreground is handled in an unusual manner.

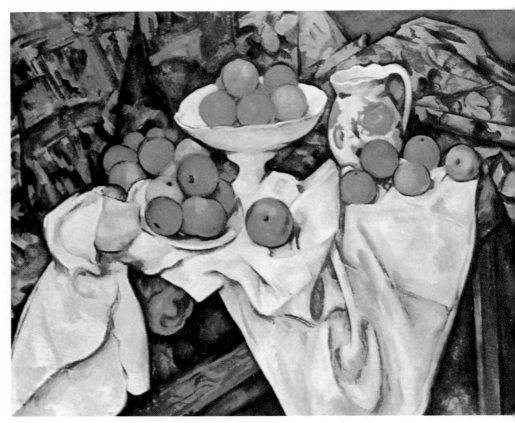

Paul Cézanne. *Still Life with Sugar Bowl* (detail). Cézanne's still lifes are considered masterpieces of composition. In this painting he has brought together diverse elements and given them unity by their positioning on the white cloth.

CENTER OF INTEREST

Does a picture need a *center of interest* or *focal point?* The famous English art critic John Ruskin thought it did. He likened a painting's focal point to a meal's main dish and a speech's main theme.

You can find many works of art where the artist places unity and diversity second to the picture's principal center of interest. Study the *Presentation of the Portrait of Marie de Medici to Henry IV of France,* page 82. This is one of 21 paintings Peter Paul Rubens painted for Marie de Medici. Henry IV married Marie de Medici. She lived in Florence, Italy and he lived in France. The painting shows the moment when the king recognized the picture of his future wife from an oil painting of her.

With this information as background, look at the composition. All parts are less important than the center of interest, the portrait of Marie de Medici. The portrait is in the center of the painting. The rectangular form and the dark value of the frame create a focal point that arouses interest. It uses contrasting color and shape.

The figure of the presenting angel on the left is emphasized by using light and shade. Light colors are used on a dark background. The angel is in a good position to direct our eyes to the portrait.

Athena, the goddess of wisdom, is advising the king on his choice. They are gazing at the portrait. Jupiter and Juno, the couple above, symbolize married bliss. They bring our eyes back to the center of attention, the portrait.

Everything except the two cupids at the bottom of the painting is dependent on the portrait of Marie de Medici for its position. This dependence is emphasized by the use of form and color. The figure of the king looks directly at the center of interest. He has an expectant demeanor, and an expression of admiration. This and his stance— even the positioning of his cane—seem to lead the viewer's gaze to the center of interest.

Now look on page 84 at another example of emphasized center of interest. It is Michelangelo's famous mural, *The Creation of Adam,* in the Sistine Chapel. There is drama at the focal point, the hand of God reaching out to touch the hand of Adam as he is brought into being. The two hands are isolated on a light background. God and His angels are gazing at Adam and Adam gazes back. All this occurs without detracting from these two hands. The hands' form, position and contrast tell us all we need to know. It is here that the center of interest is established.

On page 85, *The Adoration of the Magi* by Velazquez provides another lesson on directing the elements of a painting toward a focal point. Here the center is placed according to the Golden Section Principle. All the characters look toward the center of interest. Their poses and their wonderment compel us to pause and look at the Christ Child.

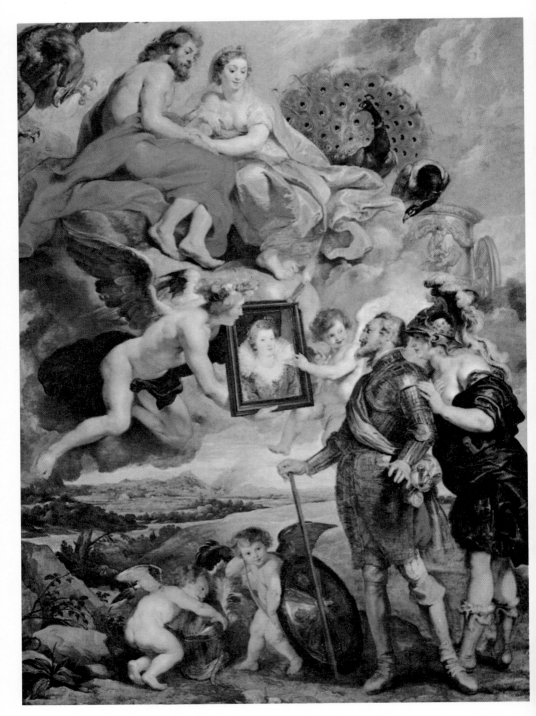

Peter Paul Rubens. *Presentation of the Portrait of Marie de Medici to Henry IV of France.* Few paintings better illustrate how to emphasize center of interest than this one. Rubens arranged the components so that all help guide the viewer's eyes to the portrait in the center. The diagrams on the opposite page break down and explain the artist's methods.

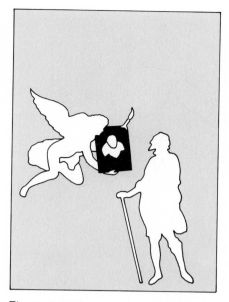

The portrait is placed in the center of the painting. It lies in the middle of a diagonal placement of elements that runs from top left to lower right, curving into the cupids.

The rectangular form and dark color of the portrait's frame call attention to it by contrasting value and shape. The presenting angel and Henry IV are both in key positions. Each leans toward and gazes at the center of interest.

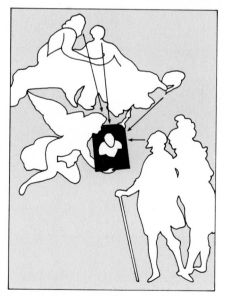

All the major figures in the painting—except for the cupids—are looking at the portrait. Even a peacock is gazing at the picture. This direction of all the figures' vision increases the portrait's dominance as center of interest. The viewer's eyes are inevitably drawn to the center.

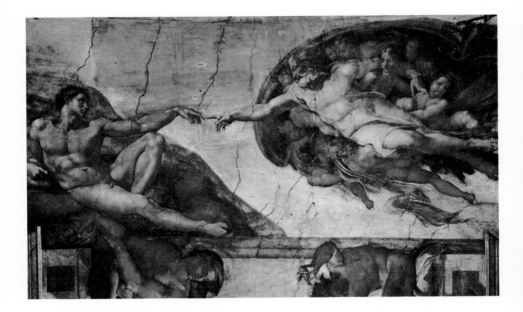

Michelangelo. *The Creation of Adam.* This masterpiece located in the Sistine Chapel presents a dramatic center of interest. The hand of God reaches out to touch the hand of Adam as he is brought into being. God, Adam and the angels are gazing toward the center, where the dark hands stand out against the light background. The outstretched arms and gazes of the figures enhance the center of interest.

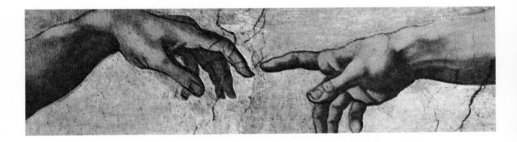

OPPOSITE: **Diego Velazquez.** *The Adoration of the Magi.* Velazquez used the Golden Section Principle to place his center of interest, the Christ Child. All the figures look toward the child. The dramatic lighting and dark background emphasize the focal point.

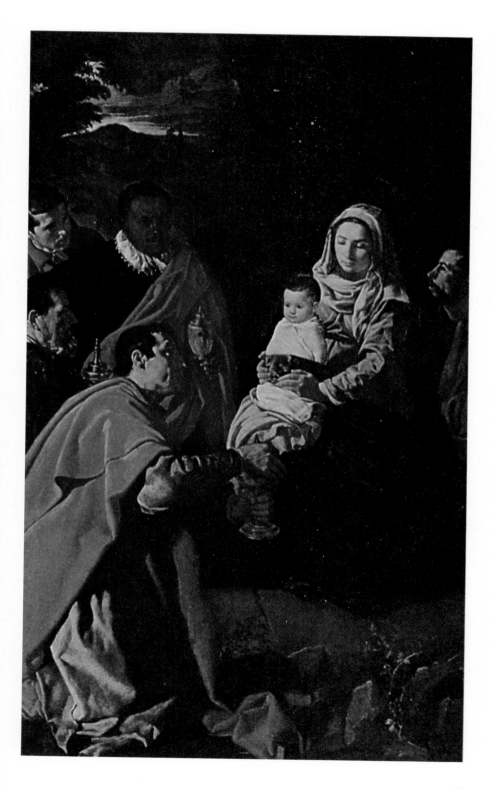

Notice how Rembrandt depicted the scene in *The Woman Taken in Adultery,* on the opposite page. He used a backward L in his composition. He balanced the clear daylight in the center with the dull glow of light around the background altar. The great empty space on the left helps to direct attention to the center of interest. This is already achieved by position, contrast of light and color and the semicircle formed by the crowd around the woman. The figure of Christ is conspicuous by its height and by the lighting.

The drama of the work is the contrast between the High Priest and Jesus. The High Priest is administering his own form of justice. Jesus is humble and holy, surrounded by ordinary, simple people as he stands in his bare feet.

The center of interest in a painting or drawing can be dramatized and emphasized by

Directing line and form.

Distribution of space and mass.

Value and color contrast.

Pose and position of figures.

There are many scenes in which it is not always advisable or even possible to have an obvious center of interest. This is often true in landscapes. Some still life subjects do not attract the viewer's attention to a specific point.

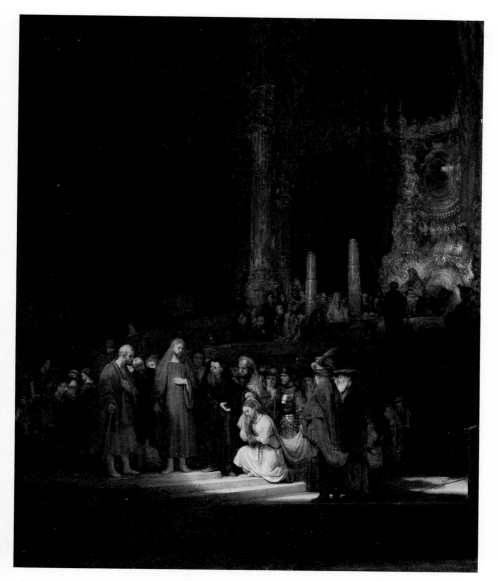

Rembrandt. *The Woman Taken in Adultery.* Rembrandt emphasizes his center of interest with techniques similar to the previous illustrations. Figures are arranged around and looking at the white-clad woman. The bright light from a window shines on the main characters. Jesus stands over the woman, gazing at her. The priest's hand gestures toward her. The woman is conspicuous because she is kneeling. Dark shadows surround the focal point. All elements in this painting are designed to call attention to the center of interest.

RHYTHM

Rhythm is present when unity and diversity combine to provide a center of interest. It is present when a composition is artistically interesting and stimulating.

Rhythm is not something that can be added or created in itself. It is the result of all elements of composition being worked out satisfactorily.

What do we mean by rhythm? We have heard of rhythmic lines, rhythmic forms, even rhythmic designs. Rhythm is associated with *smooth waves, repetitive patterns* and *cadences.*

Rhythm is *not absolute,* like line, form or color. It's not rough or smooth, thick or thin, bright or dull.

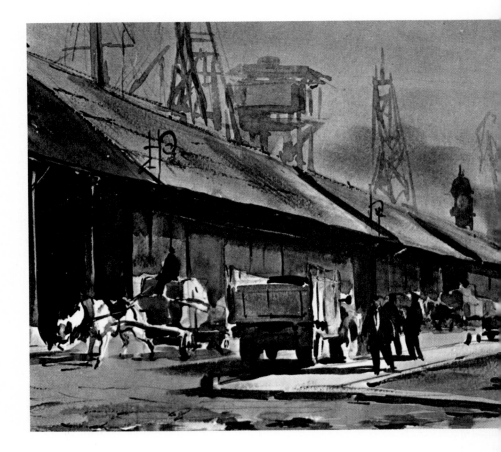

Rhythm is *the combination of different parts of a picture to produce a harmonious whole.*

There are many examples of rhythm in nature. Think of day and night, summer and winter, ebb and flow of tides, rotation and movement of the earth. These are all orderly parts of harmonious cycles. They are similar in character, but different in purpose. The tensing and relaxing of muscles is an example of rhythm. There is rhythm in the way we walk and breathe.

Let's summarize the meaning of rhythm in art: *Rhythm is order.* It is order in space, line, form, value and color. But within this order, not everything is the same. *Rhythm is diversity.* This means diversity of space, line, form, value and color.

Order and diversity must combine. They must not conflict. When they combine we say that *rhythm is harmony.*

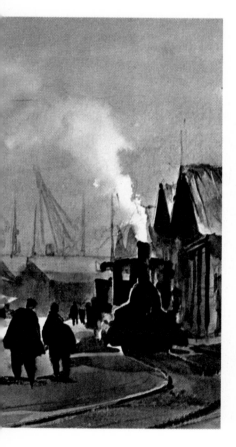

Guillermo Fresquet. Perspective, repeated shapes, overlapping elements and contrast of colors join to give rhythm to this painting of an industrial scene. Fresquet's work has strong diversity with unity. The extreme perspective draws the viewer's eye into the distance. Receding rooftops, towers and human figures create a repetitive, rhythmical pattern.

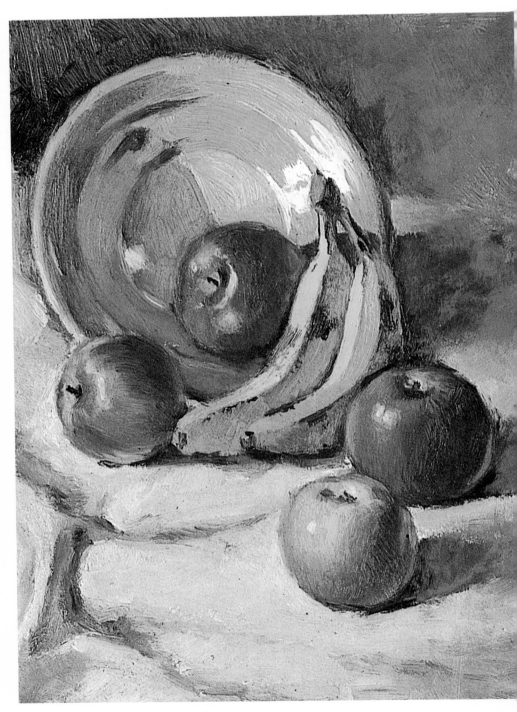

J.M. Parramon. *Still Life* (detail).

FROM THEORY TO PRACTICE 3

Choosing a Theme
Choose Objects Carefully
Lighting
Arranging the Composition
Final Sketch

Vincent Van Gogh. *The Artist's Room at Arles* (detail).

Let's try some practical exercises in composition. Some will involve simple composition with a few elements. Others will be more complicated.

Still Life

Still life is an ideal subject for the study and practice of composition. It requires careful selection of subject, practice in placing the elements and choice of viewpoint. You will learn about lighting and arranging subjects while using everyday objects as shown in the following simple sketches.

CHOOSING A THEME

Start by choosing a theme. Consider what can be done with fruits and vegetables, flowers and books. A composition could include books and an ashtray, with a lamp or china figure in the background.

Common objects in your home or studio can be used for still life sketches.

Try a still life with sports equipment or choose a guitar as the painting's main element.

How about a few mushrooms and a bottle of wine? Put in some grapes with three or four apples and arrange them on a table. Sketch a small jar containing paintbrushes, the sort of thing an artist would have around. Place some pots or tubes of color in front of them. Any of these would make a suitable theme.

Look around your kitchen. One idea leads to another. A wicker basket could inspire a still life of fruits and vegetables. A bottle of wine calls for two tall glasses, a candle and perhaps a book of poems.

Don't limit yourself. If something seems interesting, don't dismiss it if you don't have it. Borrow one from a friend.

USE YOUR IMAGINATION

Here are some more ideas: bottle, plate, cup, wooden spoon, hunk of bread, vase. Or use baskets, bowls or a bottle of olive oil. An inter-

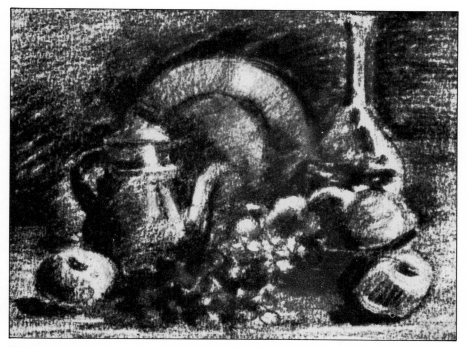

Sketch your subjects many times in different arrangements to find the composition you want.

esting pitcher on a saucer, with a spoon, fork and drinking cups would be ideal. So would a casserole, pots and pans and an earthenware jar. Use cooking pots, a couple of onions, garlic, forks and pottery jars. Still life subjects are unlimited.

TABLE AND COVERING

The table is often part of the composition. A tablecloth can be an important element without being obtrusive. It makes an ideal backdrop. Choose a dark table if possible. Then it won't detract from the objects on it. The cloth should not be new. At least the fabric should not be stiffly creased.

CHOOSE OBJECTS CAREFULLY

Choose objects that belong together. They should possess common qualities of function and design. A bottle of wine won't go well with a cup of coffee. Fish won't mix with fruit.

Try to select objects with good, basic design. Stay away from the ornate. A simple vase is better than something elaborate. Ornate items are difficult to draw and are unnecessarily distracting.

It is essential to pick objects that are attractive because of their simplicity. Choose things with well-defined shapes and contrasts in value. They should comply with the principle of unity with diversity.

LIGHTING

Should you use *natural* or *artificial* light? Many painters use artificial light when they paint and draw. It has no bad effect other than causing a slight tendency toward blue or red tints in your work. Ordinary electric light—*incandescent*—causes a red tendency. *Fluorescent* light causes a blue tendency. It's a good idea not to mix the two kinds of light when painting. This helps you avoid color errors.

Plan your lighting carefully. You should have one main source of light, usually from the front. But consider the possibility of additional light, perhaps from a reflecting surface. This can soften parts of the subject in shadow and create a better effect.

Examine the lighting of the still life in the photographs on page 95. Notice that the table is placed by a window with a shutter. You can vary the amount of light by opening or closing the shutter. This varies the shadow in the background. Look at the position of the screen. It's made of white paper over a frame. Or you can hang a piece of cloth to reflect light from the window.

Don't make the extra lighting or reflector as strong as the main source. The bottom photograph shows what happens if the reflector is placed too close to the subject. It competes with the light from the

OPPOSITE: A paper screen is used in the top photograph to reflect light from the window. The shutter can be moved to control the amount of light falling on the still life. Plan your lighting carefully. This task can mean the difference between poor and excellent artwork. The bottom photograph shows what happens when reflected light is too close to the subject. The subjects are highlighted too strongly.

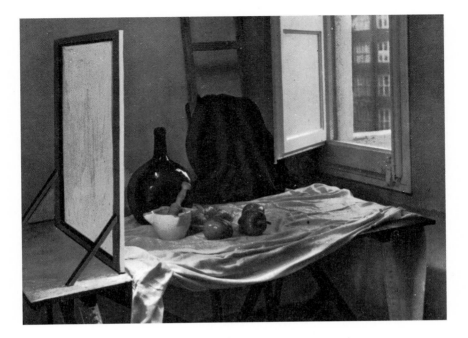

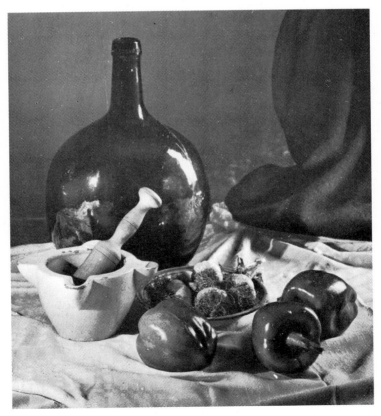

window. Objects will then lose volume and appear flat. It's more like stage lighting. Remember the basic guideline:

The subject should be lighted almost entirely from one main source and one direction. Secondary lighting should be less bright.

USING A BACKDROP

In the top photo on page 95 we have placed a cloth on the table to form a backdrop. A backdrop is not essential. Its use can sometimes spoil the effect of a composition. Make the backdrop unobtrusive. Use it to vary the scene. Let its value and color merge into the background.

ADJUSTING THE VIEWPOINT

Now is the time to consider the viewpoint of your composition. You can use a viewfinder frame as shown on pages 64 and 65. Or you can imagine the viewpoint in your mind. Make sure you have the composition exactly the way you want it. Consider several different viewpoints until you are satisfied.

ARRANGING THE COMPOSITION

You have decided on the theme, its components, background, direction of the main lighting and the viewpoint. Then you start on the most creative part, the composition. It's mostly a matter of moving objects around and choosing the best location for each one. You must work out the total effect and put into practice the principles of composition.

You can start by making two or three quick charcoal sketches, about 3x5", to see the overall effect. Judge the suitability of the chosen composition and balance various masses against others. Consider shapes, values and forms.

Concentrate on drawing masses in these small preliminary studies. Ignore smaller shapes and details until you have the larger blocks properly placed.

Sketch A below shows an L-shape composition. The objects are too small for the drawing space. This is improved in sketch B, redrawn as a close-up. Sketch B keeps the original unity and shifts some items around. This shows greater diversity.

The composition is further improved in sketch C. A slight change of lighting produces a greater contrast of overall values.

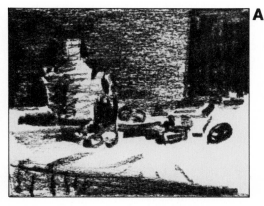

A

Subjects are too small for the size of the area.

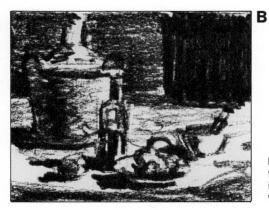

B

Proportionate sizes of the elements are better in B. There is more diversity here.

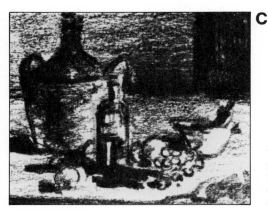

C

The third sketch shows an acceptable composition. Now you can move on to a more finished sketch. See page 98.

FINAL SKETCH

Now we have a satisfactory composition in sketch C on page 97. Next, make a larger 5x7" version, showing more detailed shapes. But don't elaborate too much. In the sketch below you can see the kind of treatment needed. This sketch gives you a model from which to begin your finished painting or drawing.

Let's study some other examples to fully understand how to arrange a good composition.

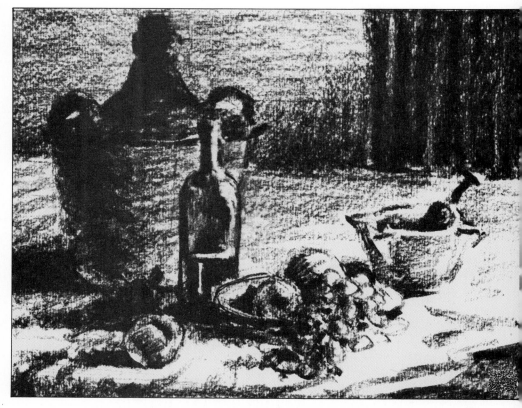

Make a larger 5x7" sketch when you have arrived at a good composition. Don't overdo the details. You can refine this sketch in your final drawing or painting.

Still Life With Fruit _____

We'll start with several pieces of fruit. In figure A below I have tried to arrange them with precision. But this is not a good composition.

We are too far away from the fruit. They are lost on the draped table and background. The fault in figure A stems from *lack of unity.* Each piece of fruit cries out for attention when arranged like this. They are scattered. They lack rhythm and harmony.

We've improved the composition in figure B by *moving closer to the*

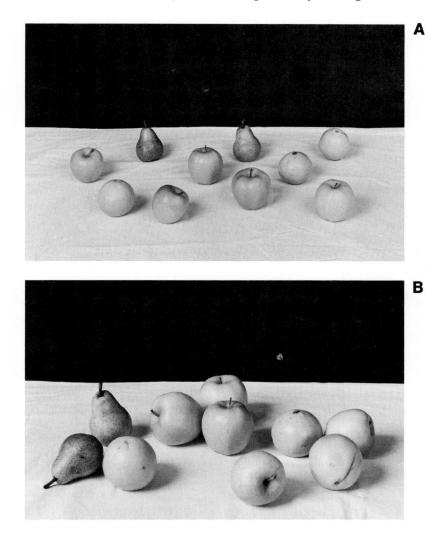

A

B

subject and *enlarging* it in the same space. Interest is increased. Objects are arranged so they form a better group. They fulfill the unity requirement in the series of receding planes.

But the arrangement in figure B has *no diversity.* This is because of the tedious symmetry of the apples and oranges. All are shown in similar positions. Their round shapes look too much alike. There is too much distracting dark background looming above the subject.

Now look at figure C below. This is a further improvement. This arrangement achieves more unity with diversity. The background has been pushed back and made less definite. Folds have been added to the tablecloth for more interest. A slight change in lighting produces

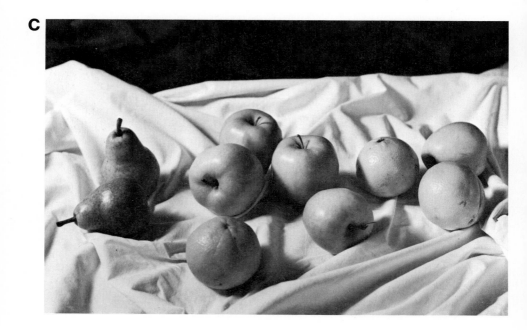

greater volume in the fruit and cloth. There are deeper and more extended shadows.

There seem to be several composition possibilities. But we've come to one conclusion. This theme is not capable of much interest. The picture has little potential.

In figure D we've made some drastic changes. There is a sharper contrast of value and form. There is greater diversity with unity. Sometimes we must get rid of some things and add others to create a good composition. Have we completed our composition of this still life? What about shifting the pitcher toward the center? The process goes on and on. Experiment with every composition until you get it the way you want it.

D

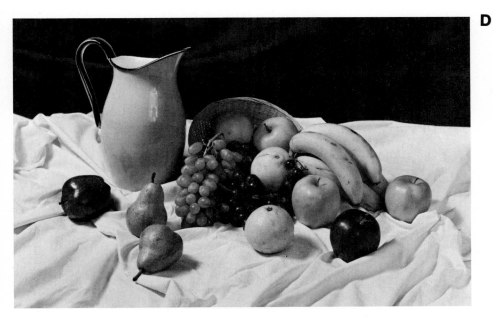

Composing a painting is an evolving process. You start with an idea, then refine it. There is no limit to the number of times you may have to revise your idea. Figure D shows the result of several tries.

Still Life With Wild Duck _____

Here we have a conventional subject similar to the famous still lifes of classical Flemish painting. The components are varied. From their diversity and number comes an ambitious theme. Perhaps there is a great picture here.

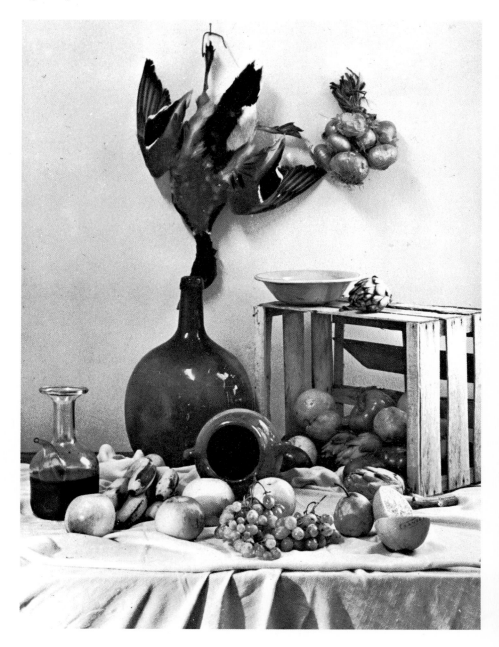

But this arrangement isn't pleasing. We have a wild duck, string of onions, glass bottle, pottery jug, jar, cooking bowl, vegetables and a great box of fruit. Let's see what we can do with all of it.

Look at figure A below. How mistakes recur! They are almost the same in a large still life like this as in a simple one. The string of onions hanging beside the duck is obviously out of place. The duck should be the center of interest, but the onions ruin this effect.

There are other problems. The duck's head appears to drop straight into the bottle. The bowl and artichoke are unattractive on top of the crate. The position of the pottery jug is awkward. It is foreshortened and almost unrecognizable.

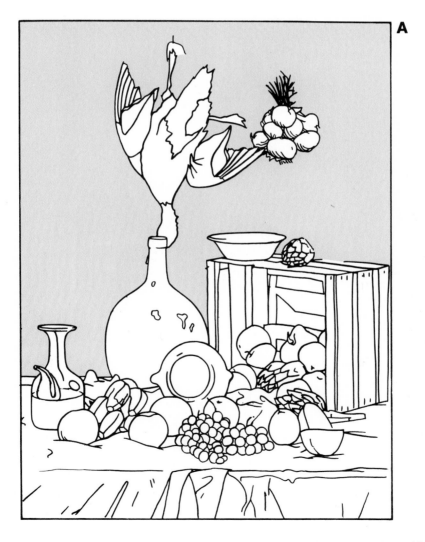

A

There is an ugly collection of tablecloth folds in the foreground. Finally, the lighting is wrong. Secondary light from the left almost overpowers the main light from the right. Let's rearrange it.

What a difference in figure B! The viewpoint has been altered. The subject is now seen from the left, from a point almost opposite the window. The reflecting surface has been removed. Now there is a clear cross-light.

The jar, pottery jug and bowl have been moved. A bunch of bananas has replaced the artichoke on top of the box. The tablecloth has been arranged more attractively.

B

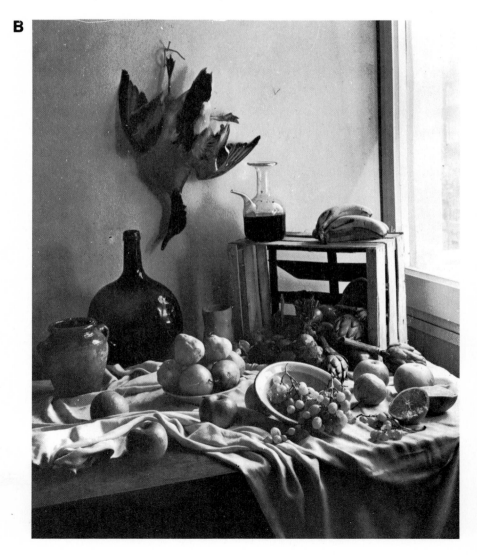

But the box facing us seems badly placed. It has more importance than it merits. Now the lighting may be *too* dramatic. Let's switch back to our first viewpoint, but leave most of our other alterations as they are in figure B.

I think figure C is the best composition of the three. The central focus and curving lines of the duck now stand out impressively. The position of the box is excellent. The improved view of the grape-filled bowl beckons the eye. It provides an attractive layout with the vegetables and fruit behind.

The composition now has a strong feeling of unity with diversity.

C

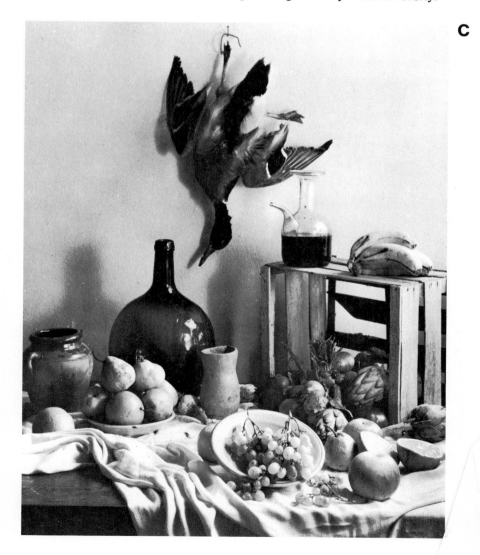

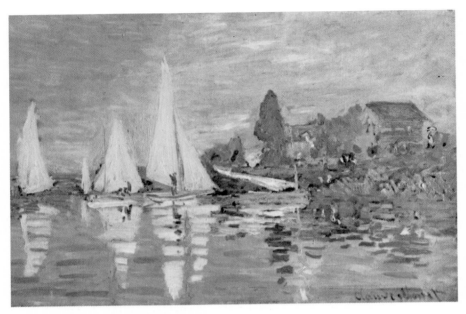

Claude Monet. *Regatta at Argenteuil.*

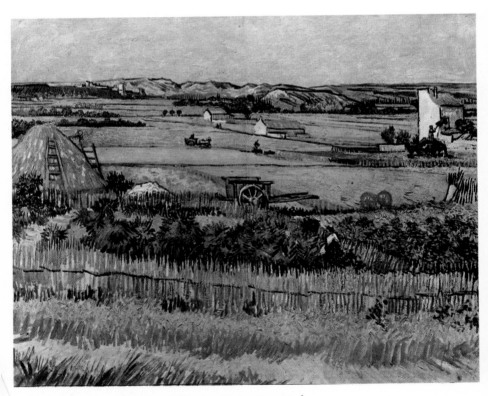

Vincent Van Gogh. *The Crau Plain* (or *Market Gardens*).

LANDSCAPE COMPOSITION 4

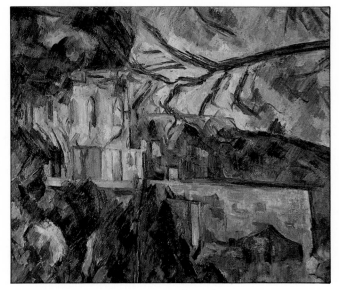

Urban Landscape
Open Country
Seascape
Lighting
Guidelines

Paul Cézanne. *The Black Castle* (detail).

Any study of landscape composition includes choosing a theme, best viewpoint and proper lighting.

Choosing a landscape subject may require some searching. A subject will turn up occasionally when least expected. This can happen when you aren't set up to paint.

Every artist comes upon a spot that seems ideal for painting. There are many picturesque places that you can paint. Use your ingenuity. Subjects are all around.

We first must distinguish between an urban landscape, the open country and a seascape. Let's study examples of each kind.

URBAN LANDSCAPE

Imagine a street in a great city, or perhaps a courtyard in a little town. Or visualize a port, a railway station, the facade of a church or cathedral. Perhaps a small-town main street, marketplace or picturesque alley of a secluded town are more to your taste. Choose what you like. There are many themes suitable in the urban environment.

OPEN COUNTRY

There are many choices of open country with no sign of urban life. These will supply plenty of suitable themes. You can try a footpath leading to a village or farm, winding here and there. Or you can paint a wooded area, sloping banks with flowers, mountain peaks or a quiet meadow.

SEASCAPE

There are infinite possibilities here. Choose a view of the port with fishing boats or ocean liners. A view of the docks, capturing the harbor atmosphere. Waves hurling themselves against cliffs. Fishing boats returning home at sunset.

LIGHTING

The characteristics and direction of light are of great importance in landscape composition. Color brilliance, values and contrasts depend on light.

Diffused natural light from a cloudy sky reduces highlights and deep shadows. This kind of light lessens the appearance of volume in the landscape and softens contrasts. Colors are tinted with bluish gray. This is even more apparent on a rainy day.

Original, high-quality work can be produced using this kind of lighting. But I think it is better to choose a *bright* day and work in *sunlight*. You can see clear colors, well-defined volume and normal contrasts.

Shadows change shape during the day as the sun moves in the sky. The sun's rays fall almost horizontally in the early morning, producing long shadows. The same happens in late afternoon.

The light is vertical and shadows are minimal when the sun is directly overhead. An upright post casts no shadow at all. Avoid these extremes. *The most favorable times of day for best painting light are between 9 and 11:30 a.m. and 3 and 5:30 p.m.*

Shadows are also at their best during those hours. Your choice of lighting angle depends on your location and that of the sun in relation to the model. Inspect the same spot at different times. Then you can judge the best moment for painting.

VIEWPOINT

Obviously you can't shift a landscape around. You'll have to move around to find the best viewpoint. You must choose whether to paint the scene from right or left, from close or far away.

GUIDELINES FOR LANDSCAPE COMPOSITION

Good landscape composition can be achieved by following these guidelines:

Emphasize the Foreground—Emphasizing the foreground gives an appearance of *depth* in landscape painting. This is accomplished through the contrasting sizes and values of immediate foreground and more distant landmarks.

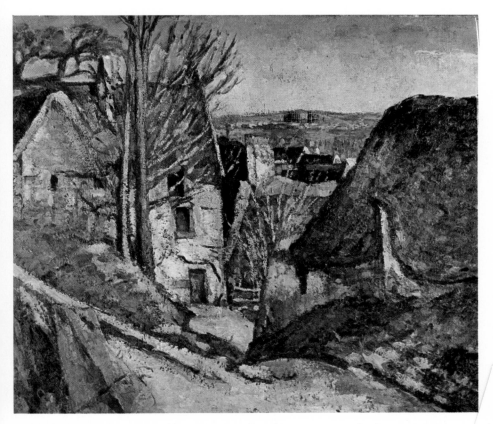

Paul Cézanne. *The House of the Hanged Man.* Cézanne's use of a light-colored foreground contrasts with the blue sky in the background. This color scheme and the overlapping of objects create the sensation of depth in this painting.

The viewer looks at a landscape with a tree in the foreground. He automatically compares the thickness of the tree trunk and the bulk of the foliage to the hills and houses farther away. This creates the appearance of *distance.*

A foreground that has contrasting colors usually contains some dark masses and other brightly colored ones. This arrangement of values produces the desired unity with diversity.

Overlap Receding Planes—You can create a feeling of depth by placing elements of the picture on different planes. This is often achieved by shifting the objects sideways in your painting. Receding planes are almost always included with a prominent foreground.

Perspective—The effects of perspective are especially seen in the composition of urban landscapes. Perspective is always evident when you draw a house, building, street or square. It's important to choose a viewpoint that allows perspective to enhance the composition.

Views that are too symmetrical or too obvious can be boring. Suppose we stand in the middle of a street. The receding symmetrical parallel lines appear to meet in the middle. We will remove the boring geometrical quality if we move to one side.

STRIVE FOR GOOD COMPOSITION

The landscape by the Spanish artist Mas y Mas on the next page is an example of good composition. Its foreground has been emphasized, producing an illusion of depth. It also shows overlapping receding planes. These unify the landmarks.

The composition contains contrasts of values and form. There is good perspective in the trees. The trees gently direct our gaze toward the center of interest, the house. This focal point is emphasized by the building's bright, whitewashed walls.

Picturesque old streets often provide the artist with unexpected inspiration. We pass by them too often without noticing their artistic potential. Once you have chosen your spot, wander up and down the street. Look at it from every angle. Explore it at different times of day to learn when the light is best.

Beware of bird's-eye views of wide landscapes with expanses of valleys and hills! They may be magnificent to look at, but they rarely provide a good painting subject. We tend to be influenced by the novelty and magnitude of great panoramic views. We become intoxicated by the air's purity.

But you can't get these intangibles onto canvas. Your painting will show only a tiny piece of this lovely vista, as if seen through the wrong end of a telescope.

In closing, remember this final thought: *There are no rigid rules or laws for composition. It's an art, not an exact science.*

Now you know there are guidelines and principles you can use to direct your creativity and enrich your artistic sense. The goal is to leave behind the *common* vision and emerge with your own view of the world as expressed through art.

Spanish artist **Mas y Mas** has followed many traditional principles to compose this painting. The shaded foreground contrasts with the sunlit background. The downward perspective invites the viewer's eye. Objects overlap and recede in size, especially the trees. The white wall of the house stands out against darker values.

8.2714597190